D

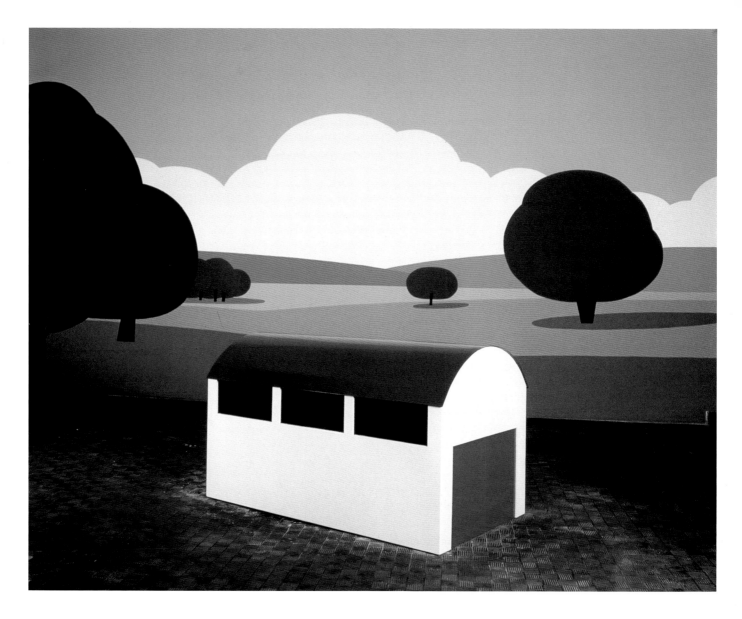

MODERN ARTISTS

First published 2004 by order of the Tate Trustees
by Tate Publishing, a division of Tate Enterprises Ltd,
Millbank, London SW1P 4RG
www.tate.org.uk

British Library Cataloguing in Publication Data
A catalogue record for this book is available from the
British Library
ISBN 1 85437 470 2
Distributed in the United States and Canada by
Harry N. Abrams, Inc., New York
Library of Congress Cataloging in Publication Data
Library of Congress Control Number: 2003104326
Designed by UNA (London) Designers
Printed in Singapore

Front cover (detail) and previous page: *English Landscape (1)*
1995

Overleaf: *Underwater* at Sadler's Wells, London 2000

Measurements of artworks are given in centimetres, height
before width and depth, followed by inches in brackets.

Author's acknowledgements

Thank you very much to Julian Opie for being articulate,
honest, generous and patient at all times; Claire Bishop,
Darian Leader and Chris Stephens for editorial advice; my
mother for her eagle eyes; Lewis Biggs and Nicola Bion at
Tate Publishing for making it happen.

Artist's acknowledgements

Thanks to all those who have helped me get the work out
into the world – galleries, museums and craftspeople – in
particular the Lisson Gallery for twenty years of support and
promotion. It has been a great pleasure to work with Mary
Horlock – the book would never have happened without her
patience, diligence and insight. I am also very grateful to
Lewis Biggs for including me in this series. Above all, thank
you to the Tate: they have kept my spirits up and my work
on view.

JULIAN OPIE

Mary Horlock

Tate Publishing

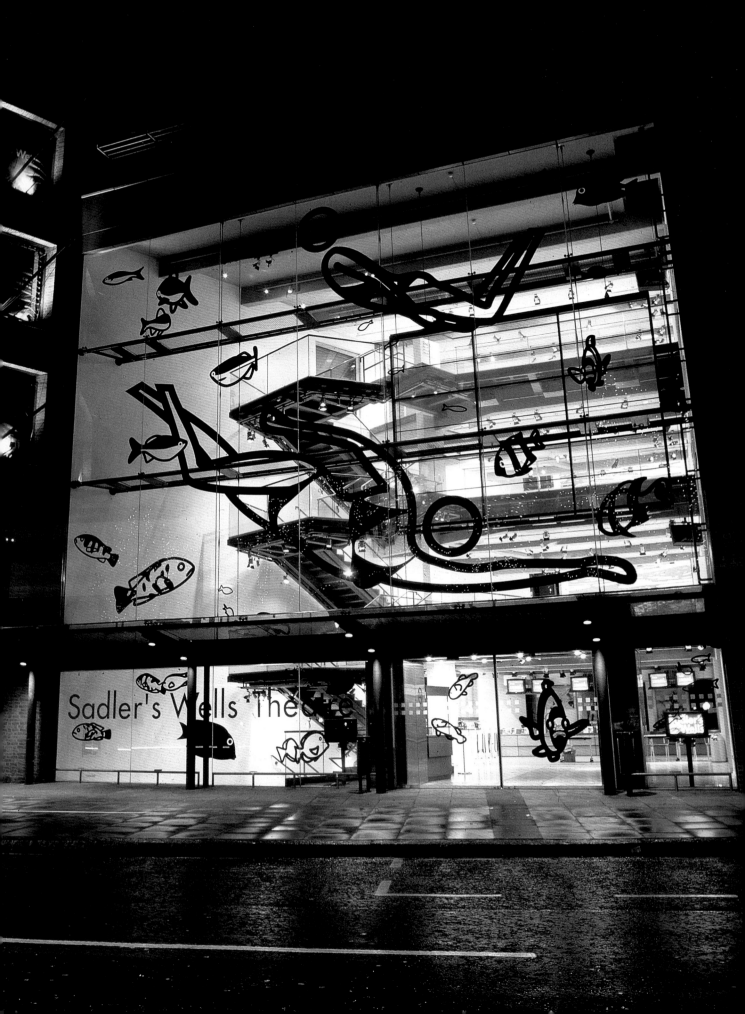

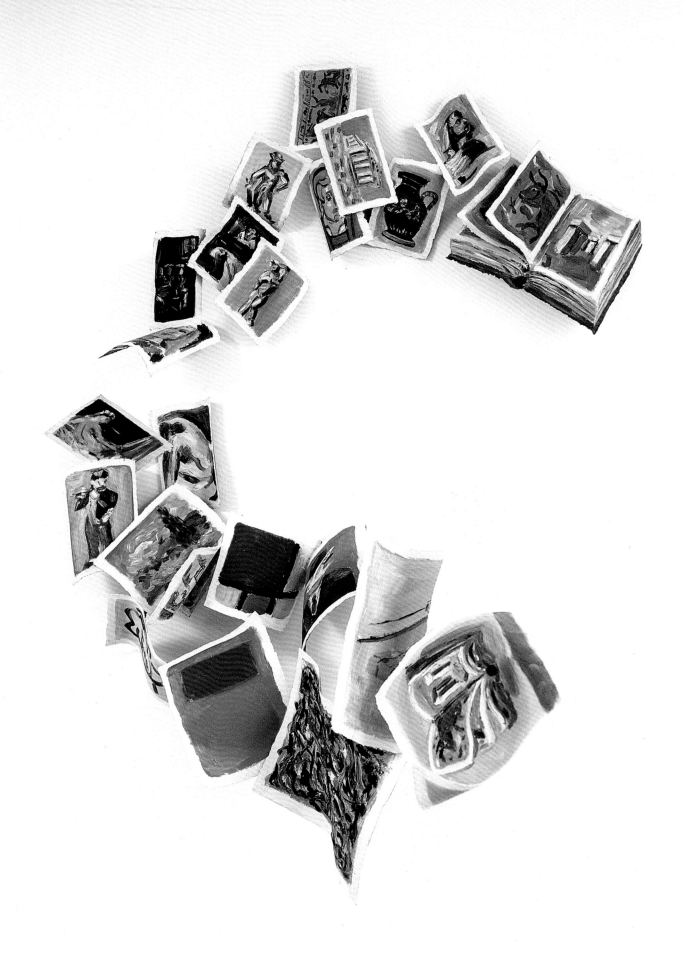

Hergé
Page extract from *The Seven Crystal Balls* (*The Adventures of Tintin*) [2]
First published in Great Britain in 1962
Hergé/Moulinsart

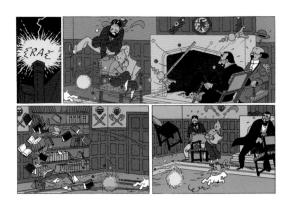

INTRODUCTION

During one of the interviews around which this book is structured Julian Opie described to me the first film that he made. It was a short piece of animation dating from his second year at Goldsmiths College, and arose from his interest in life drawing:

Whilst drawing, I saw how each image went through a series of transformations. So I worked up a sequence of simple line portraits and I layered the drawings to animate the image, pushing it through various changes. It was just a portrait of someone's head but I turned it into an inventory of styles; so it would first be sharp-edged and spiky, like a Futurist portrait, and then it went soft and classical, and then it would become broken up and Cubist. It was as if a series of lenses had been put over someone's face and these lenses were art-historical styles.[1]

This film and Opie's description of it provide insight into his project. From the outset he has experimented with codes and conventions of representation, exploring the power of images and their relationship to perception and recognition. Opie has constructed his own language to reveal the ways in which we 'read' the world. The subject of this first animation – picturing the human form through the canonical styles of art history – shows how Opie's interest lies not in 'reality' but in how reality is represented to us, an idea that recurs time and again. In a sense, Opie has always been making representations of representations: paintings of paintings, models of models, signs of signs. His art reflects the artifice that frames contemporary experience.

This film also demonstrates the consistency of Opie's methodological approach. As an animation, it came out of drawing, which has always been his focus. Line drawing manifests a particular rigour and economy; it emphasises the essentials and this has consistently distinguished Opie's work and given it

immediacy. What we see in this film is line drawing transformed into something else, into animation. Moving from drawing into different media and developing (often simultaneously) many different bodies of work, Opie is constantly on the move. Working in series, he has made his drawings into films, sculptures in steel, wood or concrete, paintings, billboards, CD covers, road signs and screensavers, discovering and defining multiple forms for a single image or idea.

This early film, then, hints at what is to come in Opie's oeuvre: the mixing and re-mixing of high art, the juggling with strategies of representation, the working in series and experimenting with new media, and all of this filtered through the commonplace scenarios of everyday reality. It is through such means that Opie makes us aware of the complex relationship between what we see and what we know. This book traces the development and diversification of his artwork from the early 1980s through to the present, and provides an opportunity for Opie to comment on his work. He is extremely articulate about his projects and his way of speaking is direct and matter-of-fact, qualities that are quite in keeping with his art.

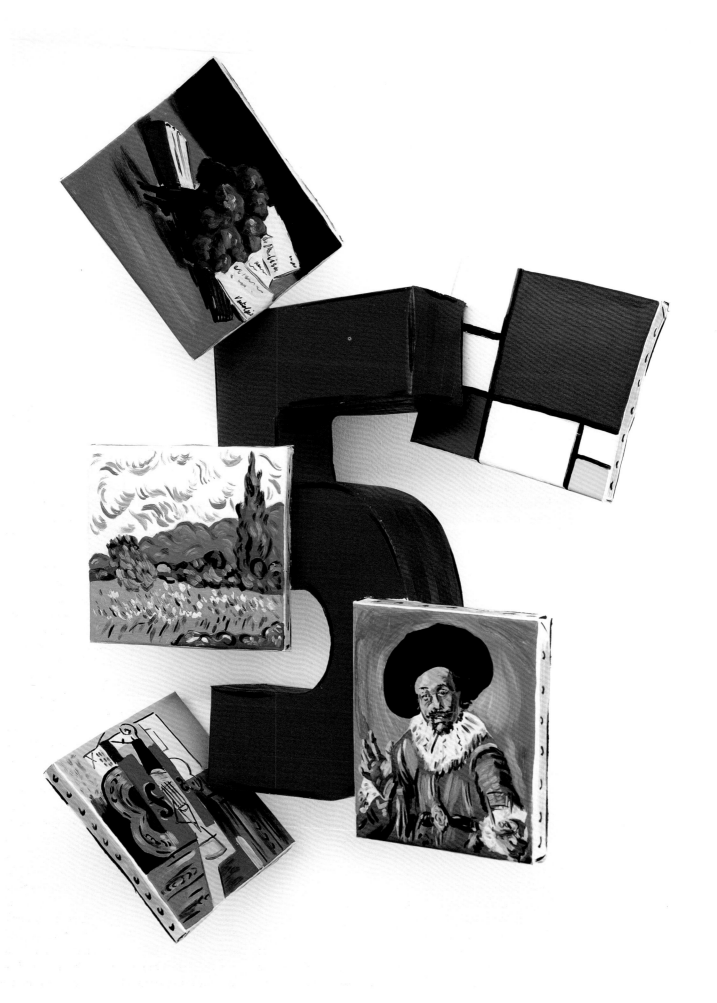

FIVE OLD MASTERS 1984 [3]
Oil paint on steel
150 x 120 x 70 (59 x 47 $\frac{1}{4}$ x 27 $\frac{1}{2}$)
Private Collection, USA

ANDY WARHOL 1964
BRILLO BOXES [4]
Silkscreen ink on wood
43.5 x 43.5 x 35.6 (17 $\frac{1}{8}$ x 17 $\frac{1}{8}$ x 14)
Norton Simon Museum, Pasadena,
CA. Gift of the artist 1969

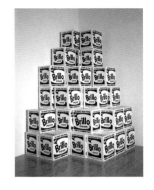

EAT DIRT ART HISTORY

Julian Opie was born in London in 1958 and brought up in Oxford, where his mother was a primary-school teacher and his father an economics don at New College. He was a student in London, completed his foundation year at Chelsea College of Art, and then studied for his BA at Goldsmiths College, graduating in 1982. In those early years, he devoted most of his time to life-drawing, a surprisingly conservative beginning, but Opie soon benefited from the open, innovative atmosphere at Goldsmiths. By that time there was no house style and the divisions between art departments had long been abolished. Students were encouraged to work in any medium they chose, and Opie tried everything – making paintings, models, sculptures and films. He was remembered as an intelligent, restless and prolific student, impatient to transform his ideas into material reality.

An anti-authoritarian and anti-specialist mood informed the art of the early 1980s; there was much talk of collapsed systems, of how knowledge had become fractured and fragmented, of how originality had disappeared. Opie's peers at Goldsmiths – among them Lisa Milroy, Andrew Carnie, John Chapple – were all making figurative work, perhaps as a reaction to abstraction and Minimalism. Opie acknowledges that 'Our attitude towards art history, towards schools, styles and "isms", was quite aggressive. We wanted to manipulate them, to use whatever style we wished.' His classmates shared an attitude of ironic detachment, an interest in the commonplace, an indifference to the divisions between high and low culture, and all of this fed into their work.

The boundaries between art and everyday life had long been rendered indistinct, thanks in no small measure to the divergent strands of Minimalism and Pop art, both of which offer a kind of context for Opie. It was Marcel Duchamp who, in 1917, had first taken an everyday object (a urinal) and placed it in an art exhibition, thus questioning the uniqueness of the artwork amongst the multiplicity of all other objects. Equally, Duchamp refuted the notion that art had to be complex in order to offer a complex experience. Although diverging from Duchamp in significant ways, Minimalism shared some of these concerns. The urge to clarify aesthetic experience prompted artists such as Donald Judd and Carl Andre to make works of stark geometric simplicity, devoid of decoration and expressive technique, and fabricated out of unworked industrial materials. Significantly, the Minimal art object was coterminous with the space of the viewer, bringing sculpture into the real space of the real world, where it would remain.

Pop art, like Minimalism, borrowed from non-art conventions and languages, but did so by making images that were resolutely representational, pillaging mainstream visual culture, using imagery from TV, newspapers, advertising, and the work of other artists. In America, artists like Claes Oldenburg, Andy Warhol and Roy Lichtenstein, and in Britain Richard Hamilton and David Hockney, chose images that were pervasive, persistent and persuasive, seeking out the iconic in the world around them. Warhol recognised that basic commodities could be treated as art, an attitude reflected in multiple objects such as *Brillo Boxes* 1964, a carefully painted replica of a ubiquitous cleaning-product package. Pop art was wrongly criticised for its lack of political content: its insistence on art's immediacy and currency was in fact implicitly political. Pop artists adapted the full spectrum of pre-existing artefacts, signs and symbols for their subject matter. Ultimately, they incited considerable debate about the commodification of art and the passivity of the individual in the swell of consumer culture. This idea had ramifications in the

Michael Craig-Martin
READING WITH GLOBE 1980 [5]
Drawing and acrylic on plastic
Tate

1980s, particularly in America with the work of 'commodity' sculptors like Jeff Koons and Ashley Bickerton, and in England through the recycling of consumer durables by sculptors such as Tony Cragg and Bill Woodrow.

Like many of his peers, Opie learned from the matter-of-fact language of Minimalism and its desire to communicate directly, but rejected its insistence on abstract form and avoidance of metaphor. Instead he preferred to ground his work in figuration and he used recognisable imagery much as the Pop artists had done, interweaving references from art and ordinary life. His first exhibited works were sculptures of accumulated objects – a stack of books (*Incident in the Library II* 1983), a heap of canvases (*A Pile of Old Masters* 1983), passports, credit cards, envelopes and cheques (*Personal Effects* 1984) – pulled together in a casual way. Many critics were quick to see Opie as a successor to Pop art; a verdict that was confirmed not only by his style but by his source material (1940s romance book covers, Hergé's *Tintin* cartoons, basic food packaging). Commenting on this early work the critic Marco Livingstone wrote:

The jocular tone and simple forms of representation, both of which masked the technical complexity of the structure … were clearly intended to entice a mass audience in much the same way as the most exuberant forms of Pop art had done twenty years earlier.[2]

Opie used common imagery to construct a standardised visual language, but although he was interested in the physical characteristics of everyday objects, he avoided specifics. His objects were generic, universal – like signs or templates. Such a strategy was clearly connected to Conceptual art, and more specifically to the work of the American-born artist Michael Craig-Martin, who

taught Opie at Goldsmiths and later took him on as a studio assistant.

Craig-Martin had moved to England in the late 1960s, and through his artistic practice as well as his writing and teaching he instigated a thorough enquiry into the nature of art and strategies of representation. Whereas Minimalism had placed the emphasis on simple geometric forms to create the most direct relationship between art object and viewer, Craig-Martin would propose that 'everyday objects of use' were the real primary forms – items like books, chairs and tables. He constructed a basic vocabulary using an even more basic style of line drawing, stripping the detail from each object to make it appear more like a sign. He then combined these representations in wall drawings. Their neutral, black on white outlines encouraged us to consider what qualities define an object, how object and image differ, and how we might interpret them.

Craig-Martin and Opie were both mining the everyday to construct a recognisable visual repertoire of items. Opie would always stress that he did not sculpt or paint his objects but drew them, and that he always depicted 'the classic idea of that object, the kind that you would draw for a person that couldn't read'.[3] Craig-Martin and Opie shared an interest in the psychology of perception, and in the complexities of reality, representation and recognition. However, Opie's art was very different from Craig-Martin's in its material reality. Opie was drawing, but with an oxyacetylene torch, using it to cut into steel, then bending and folding it into shape. His sculptures were roughly made and casually combined. He took liberties with scale and adopted a way of painting that was flamboyant and stylised, using bright, primary colours and trompe l'oeil effects. Mel Ramsden and Michael Baldwin described his assemblages as 'frozen

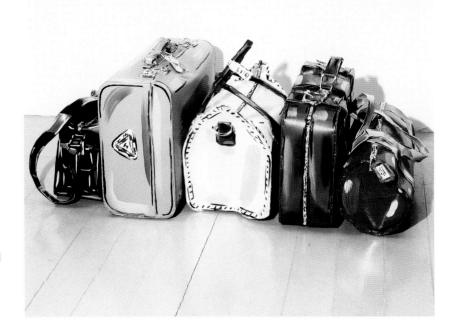

PROJECT FOR HEATHROW 1985 [6]
Oil paint on steel
45 x 140 x 60 (17 3/4 x 55 1/8 x 23 5/8)
Mr & Mrs Leaman, New Orleans,
USA

moments of pantomime'.[4] There was none of Craig-Martin's neutrality. The work exuberantly proclaimed itself hand-made and hand-painted. When Craig-Martin selected Opie for a group show at the Riverside Studios in 1983 he characterised the work as highly expressive and assertively physical, 'explicitly using physicality (objectness, materiality, space, both actual and illusionistic, scale, placement, etc.) to carry both meaning and expression'. He also noted how 'its desire to engage the viewer directly and without mystification is palpable'.[5]

Perhaps it was predictable that a recent art-school graduate would make works steeped in references to art history and to other artists, and *Eat Dirt Art History* 1983 is one such example. In this sculpture, the pages spill out of an open art-history book, scattered in a sweeping circle across the wall. Each page offers up improvised versions of works by Manet, Mondrian, Pollock and Rothko – there is enough information in each image for the artists to be identified, but they are merely pictorial suggestions. The work trumpets Opie's knowledge of the past and his desire to overcome it, but there are other levels of meaning: the last, largest sheet in the circle offers a second reproduction of the open book, the very source from which all these images had been pulled. This suggests that the fate of art is one of succumbing to successive re-representations. For Opie (as for Lichtenstein and Warhol) art was yet another aspect of mass-produced culture. Sculptures like *Five Old Masters* 1984 or *15 Monets* 1985 mock the mass reproduction of iconic works of art, although their hand-made aesthetic adds a fresh aura of authenticity.

Opie's art about art was knowing and ironic. *Clean Abstraction* 1983 depicts a dustpan and brush, a sponge, cloth and floor mop, busily tending to the surfaces of minimal, grey forms as a bucket and cleaning product stand nearby. While they seem to be tidying these shapes – hence the pun in the title – they actually sully their formal purity. Another work from the following year, entitled *I was thinking of Barnett Newman*, presents us with two equal sets of neatly arranged, horizontal rows of enlarged cigarettes mounted on the wall – giving the formal geometry of modernist abstraction a figurative spin.

In these works, objects were strung together like words forming a sentence. A basic narrative was key: *Five Letters* or *Four Parking Tickets* from 1984 represent exactly what the titles describe. In *Call Me* the words of the title, in block capitals, dance around well-worn copies of telephone directories. Opie is wearing his heart (and his youth) on his sleeve. He was in his early twenties, and the energy and bravado in these constructions, as well as their light-hearted, often romantic, subject matter reflects a youthful naivety. Opie knew that his young age permitted him to make light of things:

I was aware that there were dangers in making art funny, as you will alienate certain people ... but many people were ready for that and enjoyed it. The humour also came out of a desire to undermine authority. It's a way of communicating with the viewer, saying 'I'm on your side.'

The critic Andrew Graham-Dixon seemed to agree, recalling that 'this was art as spring-cleaning; a breath of fresh air'.[6]

When Craig-Martin brought Opie's work to the attention of Nicholas Logsdail, the Director of the Lisson Gallery, he showed immediate interest. Opie was included in a group show at the Lisson after graduating, with solo shows in 1983 and again in 1985. He also had a solo show at the Institute of Contemporary Arts in London in 1985. Such early success was unprecedented in the British art scene at

CLEAN ABSTRACTION 1983 [7]
Oil paint on steel
220 x 120 x 80 (86 5/8 x 47 1/4 x 31 1/2)
Annina Nosei Gallery, New York

ABSTRACT PHASE NO. 1 1983 [8]
Oil paint on steel
120 x 80 x 80 (47 1/4 x 31 1/2 x 31 1/2)
Private Collection, London

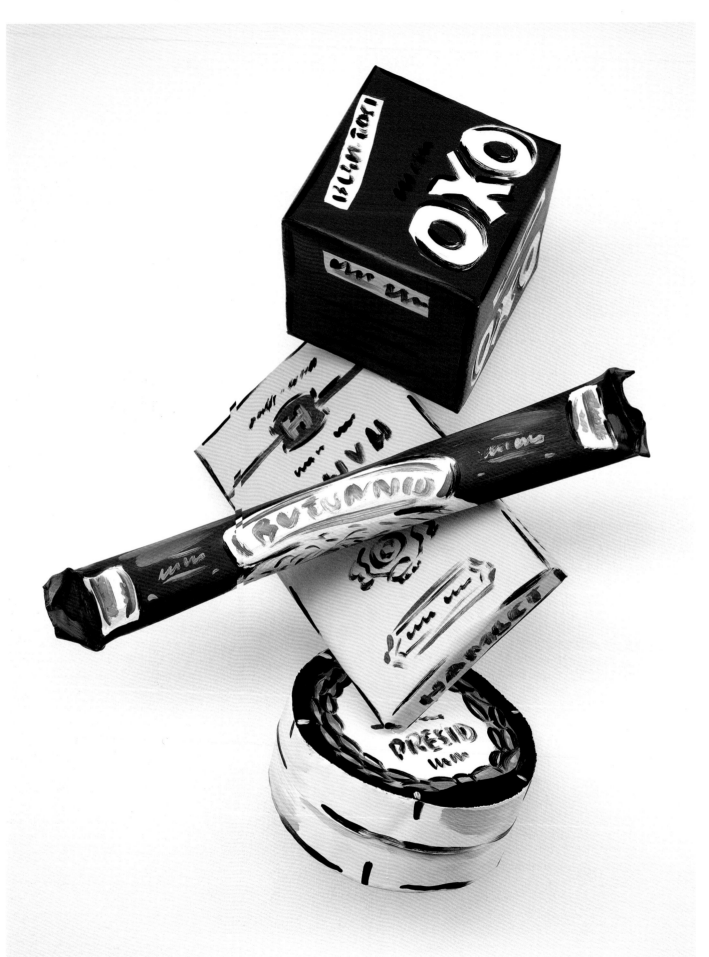

this time, and the reviews focused on his youth and precociousness. Richard Cork was not alone in worrying that 'Slickness is a dangerous weapon to employ, however ironic the purpose may be', and that the work could be 'easily absorbed and almost as easily exhausted'.[7]

Many faulted Opie's sculpture for being pictorial, but that was its intention. Opie would maximise the ways in which the object's appearance belied its true nature: there is a tension between the solidity of the actual object and the painted fiction applied to it. Space is presented as both literal space, in which we confront the object, and as depicted space, achieved through painted highlights and shadows. There was also the inevitable disjuncture between front and back – the front was treated in this casual, painterly style, and the back was unadorned and raw. We might be drawn in by the painterly illusionism, but we soon see the bare, structural facts that the back-view betrays. The tension between image and object, surface and structure, led Opie to suggest that his sculptures were like quick 'magic shows', where the audience would be fooled by a momentary illusion, with the trick explained to them afterwards.

Opie was neither a painter nor a sculptor in the orthodox sense. His works were paintings as much as sculptures, and sculptures as much as fabricated objects. He would complicate this by consciously making sculptures out of 'paintings' or 'paintings' out of sculptures, literally conflating the two media. Thus, A Pile of Old Masters 1983 is a heap of copies of famous artworks casually strewn on the floor, whilst in Legend of Europa 1984 the box-like forms of OXO cubes and a cigar packet are jazzily thrown together and fixed to the wall.

Opie used steel because it was practical and versatile. He was resistant to any association with the 'boring macho tradition' of welding, and by this he meant the formalist modernist abstraction of sculptors such as David Smith or Anthony Caro. But the way in which he used steel to create compositions full of movement does relate formally to the work of both Smith and Caro. Opie came to see Smith's sculptures, notably those from the 'Cubi' series, as the classic archetypes of modern sculpture. Typically, he made his own versions of them, creating mock-ups utilising everyday artefacts such as cartons and packages bought in supermarkets. Legend of Europa is one such example, owing its title to the supermarket chain from which the depicted items were purchased. Elsewhere, the tumbling composition in works like Eat Dirt Art History or Call Me have affinities with the poised constructions of Caro, sculptures that strike a balance between disparate elements, sealed in a painterly skin to create a sense of weightlessness.

With hindsight, the fact that Opie's works resembled, before they were painted, a Caro or a Smith was indicative of the direction in which he was moving – towards bolder, simpler forms. As he began to refine and improve his methods of fabrication, the sculptures became more static and solid.

By 1985 I could afford to buy large sheets and I'd bought a good welding tool. That made for a much more 'finished' object, although it slowed things down. Inevitably the compositions become more static, cleaner. Sensible moves do slow you down. I didn't like losing momentum but had a sense of responsibility to make something properly.

This is more than apparent in the tidy row of suitcases in Project for Heathrow 1985, where the smooth, evenly painted surfaces of the luggage lacks the energy of the earlier works. Opie was sensing that he had come close to exhausting the possibilities of this body of work.

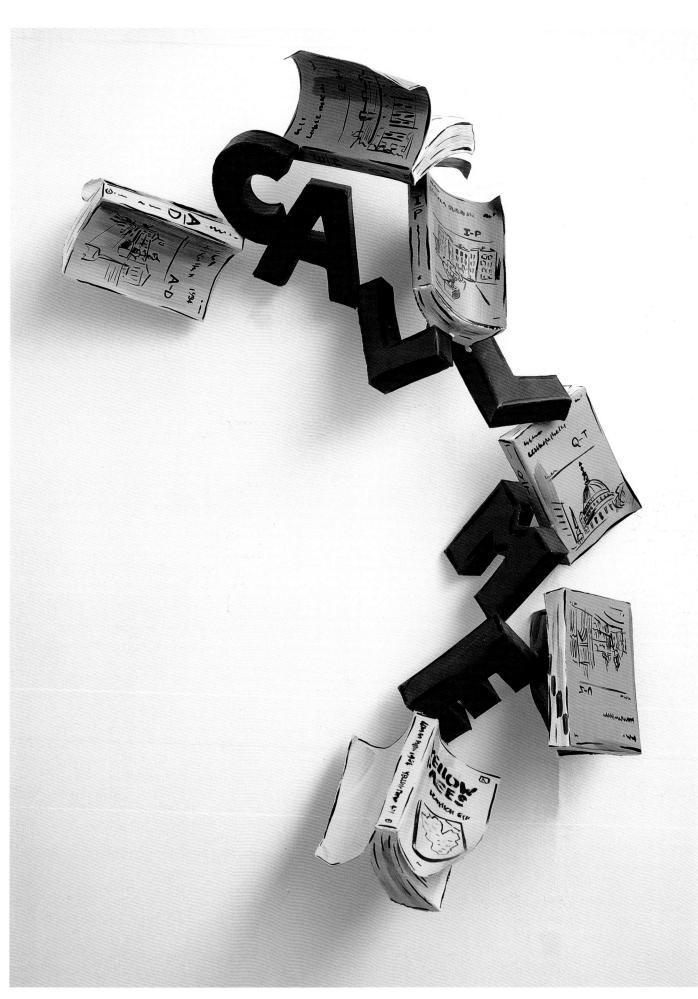

CALL ME 1983 [10]
Oil paint on steel
160 x 130 x 60 (63 x 51 1/8 x 23 5/8)
Private Collection, Germany

FIVE LETTERS 1984 [11]
Oil paint on steel
75 x 32 x 24 (29 1/2 x 12 5/8 x 9 1/2)
Private Collection, USA

MARY HORLOCK During the early 1980s you were making art about art. Why choose to create new versions of *Old Masters*?

JULIAN OPIE Well, some years before this I was drawing canvases – stretched canvases – so in a certain sense what attracted me was the object itself: the rectangular shape with nails down the sides. Everyone can recognise it: it's an object of shared language and it's a simple and funny thing. At art school I'd started making copies of famous artworks – a series called 'Eat Dirt Art History' – where I'd draw, say, an El Greco very loosely in pen and ink and write underneath it 'Eat Dirt El Greco'. I pinned these drawings around the school. It was an acknowledgement of the hopeless position of the art student in light of art history, but also a rally call not to feel overwhelmed by it.

MH It is quite irreverent. Were you trying to say that you could 'do' a Picasso or a Mondrian?

JO It was a self-conscious time, and I was making self-conscious art objects. I assumed that anyone looking at them would be mistrustful, and I wanted to address this and defuse it. What *A Pile of Old Masters* was proposing was kind of preposterous – that I could outdo art history. But I wasn't really challenging El Greco. And I was also using this shared language of reference to give the work a legible narrative.

MH And how did you select these particular images?

JO They're probably the artists and the paintings in the book I had closest to hand. It was necessary that they were recognisable, and easy to copy.

MH Roy Lichtenstein painted his own versions of famous paintings. Did you see any connection with Pop art?

JO Well, I would have been aware of Pop art. It was art, but it was outside academia. It didn't feel like history. It felt modern and that was attractive. Generally art about art was unpopular at that time, and those works you're talking about are not my favourite Lichtensteins.

MH But you could say that Lichtenstein had a similarly irreverent attitude to art history.

JO Yes, but Lichtenstein is much more serious-minded than you'd think. He used humour like other people use colour. He saw that it was no longer possible to consider certain images without irreverence. When you think how most people know the famous works of art history through postcards,

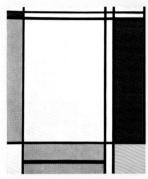

Roy Lichtenstein
NON-OBJECTIVE 1 1964 [12]
Magna on canvas
142.2 x 121.9 (56 x 48)
The Estate of Roy Lichtenstein

overleaf: A PILE OF OLD MASTERS 1983
[13]
Oil paint on steel
14 parts: 37 x 37 x 6 (14 $\frac{1}{2}$ x 14 $\frac{1}{2}$ x 2 $\frac{3}{8}$) each
Dimensions variable
Private Collection, Switzerland

that's irreverent by its nature.

I could have drawn an apple and a pear, but drawing a Cézanne felt more honest: what I really wanted to do was draw a Cézanne, or a Lichtenstein for that matter. One of the possible thoughts when viewing this work is 'This is irreverent', but it's also deeply reverent. I knew the first thing that people would think was 'Here's this young artist who's just come in and thrown art history on the floor.' People knew I was young, and I played along with that. The point is, I had a lot of fun drawing the things that were supposed to be great – things that had become 'locked', unusable because they were so admired. I wanted to reach into this, try it out. But these paintings were things I admired very much.

MH In the centre of *A Pile of Old Masters* lies an overturned canvas with your signature on it, so you're staking your claim.

JO The flourished signature is part of the whole self-consciousness – I was pleased with myself, that I could do those things, but at the same time there's a double and triple meaning. I was told I had to sign my works and I didn't feel at all comfortable about it. So I found a way of working the signature into it.

MH The pieces aren't connected and so can be set up in different ways. Didn't you want to dictate how it's installed?

JO: It's a sculpture that relates to the space it's in. I have drawn up guidelines but you cannot say definitively what will work where. At the Lisson, this was the only work that had a relationship with the space. You approached it by going down a small flight of stairs and saw it from a distance. I placed some of the paintings on the floor and leaned some against the wall. At the Hayward Gallery [at Opie's solo show in 1994] it was in the middle of a large, open space and I set it up differently: it was more dispersed and flat.

MH When I think of painted steel sculpture, I think of Caro and the 'New Generation' sculptors. Did you deliberately set yourself up against all that?

JO Yes. It was 'right' to use sheet steel, but 'wrong' that it was figurative. By this time, Sir Anthony Caro and his 'school' were perceived as the establishment. I admire the work but as a student it's useful to have something to rant against, and this was an obvious target. Primarily I needed a material to translate the way that I drew: welding could be almost as fast as drawing a line on a piece of paper, and it enabled me to assemble things at a speed where I could think with

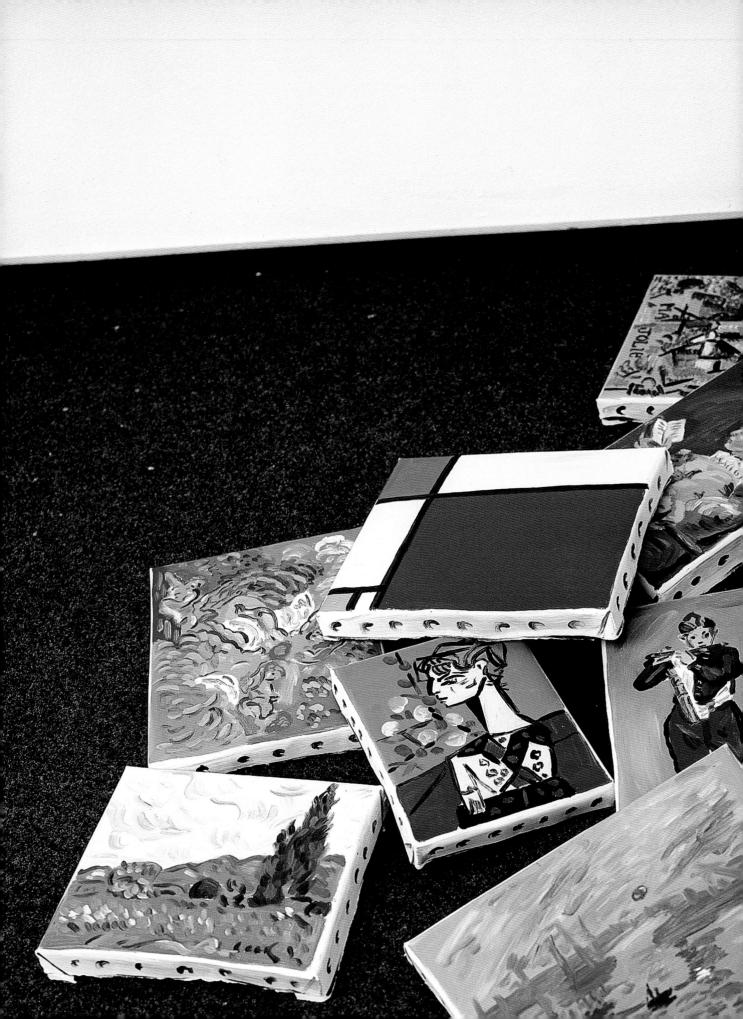

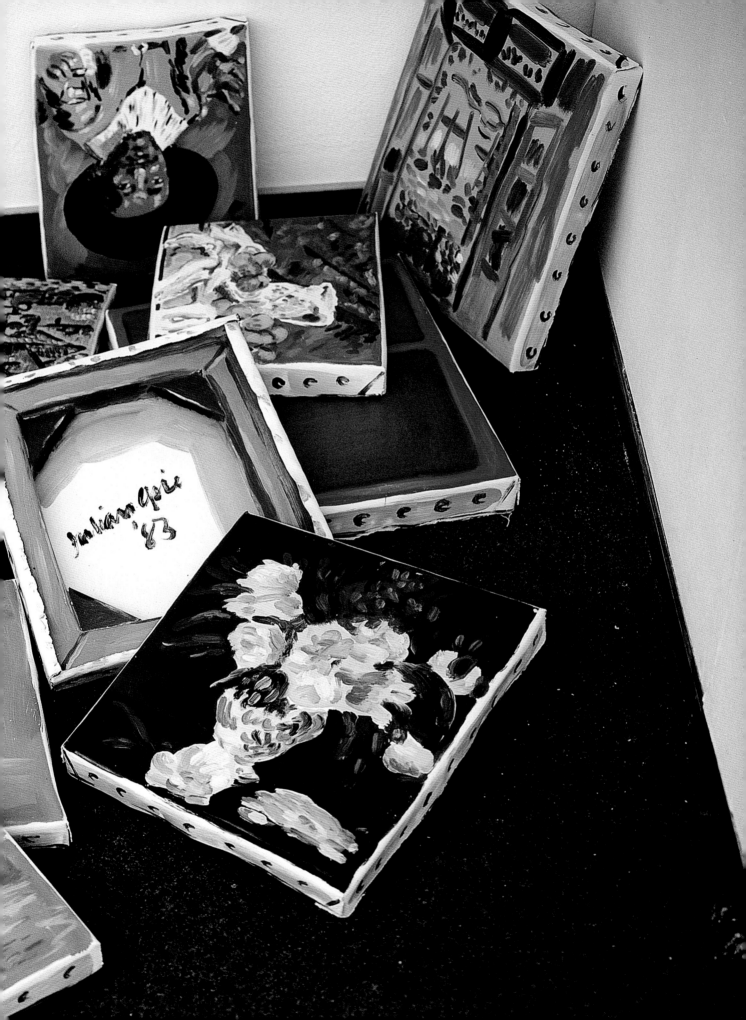

opposite: CULTURAL BAGGAGE 1984 [14]
Oil paint on steel
190 x 150 x 130 (74 3/4 x 59 x 51 1/8)
Private Collection, London

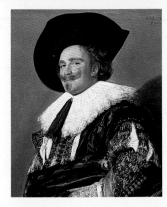

Franz Hals
THE LAUGHING CAVALIER 1624 [15]
Oil on canvas
86 x 69 (33 7/8 x 27 1/8)
The Wallace Collection

the material. It was also about the strength of steel. And it could defy gravity, so things were no longer grounded.

MH A lot of the works are about movement. Even in *A Pile of Old Masters* there's a sense that the canvases have been impulsively flung down.

JO There's a drawing by Hergé in the Tintin story *The Seven Crystal Balls* from the 1960s, where a fireball comes down the chimney and all the books are pulled off the bookshelves and spin around the library. I did copy that drawing of books flying, and I think this work has an element of that. I used to draw in notebooks constantly, refining ideas, and then make a lot of sculptures, some of which survived. I made maybe fifteen sculptures involving canvases, some with brushes, some in a circle, some tumbling out of a suitcase.

This work, which had all the canvases on the floor, needed to have actual paintings on them, whereas the ones that were spinning around worked better if they were kept blank – an image would slow them down, and if they were spinning you'd only see a blur. Making actual pictures here has a function: it anchors them. It also makes some kind of sense – these famous paintings have been thrown away. It leaves no questions unanswered. Blank canvases on the floor would have been too ambiguous.

MH Staying with this idea of speed, did you paint quickly as well?

JO Yes, I was copying artists like Hals and Manet, who used a 'wet-on-wet' style. This style of painting is about performance and energy. The look had to be slick. If the painting didn't work out you had to wash it off and start all over again. I'd paint the surface a background colour, then draw on top of that with highlights or shadows with a very loose arm movement, cleaning the brush after every stroke. Some of the paintings are better than others. The ones that were originally painted in a similar 'wet' fashion worked best – the others I tend to bury under the pile.

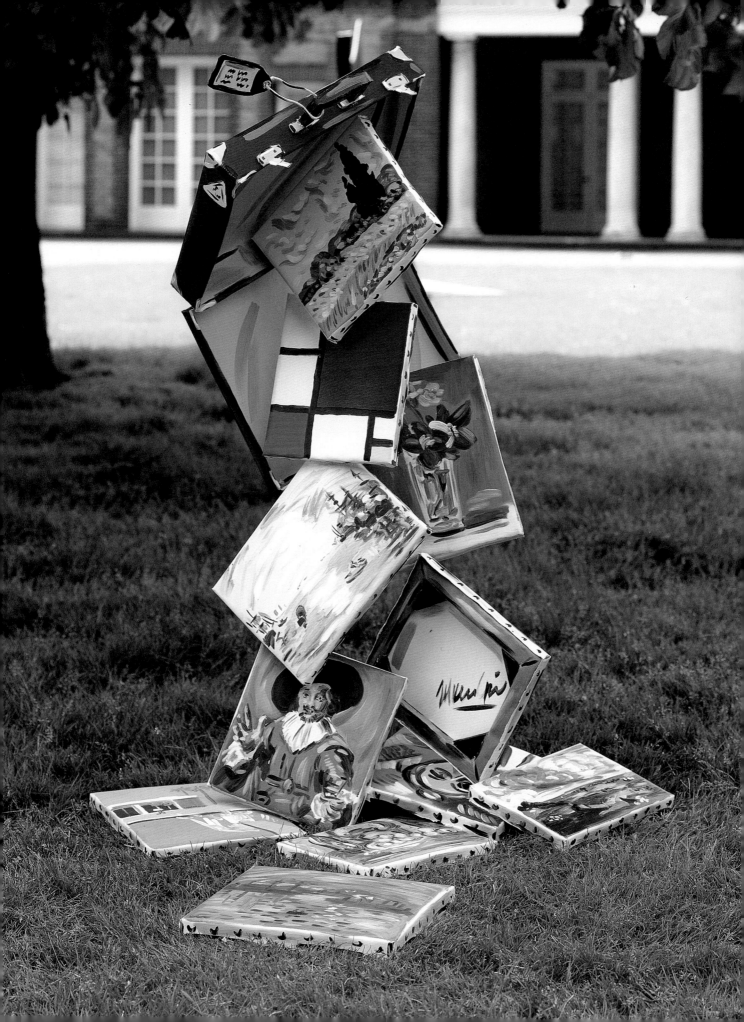

POSTAL STAFF RETURN TO WORK
1986 [16]
Cellulose paint on steel
250 x 150 x 65 (98 ½ x 59 x 25 ⁵⁄₈)
Museum of Contemporary Art,
Prato, Italy

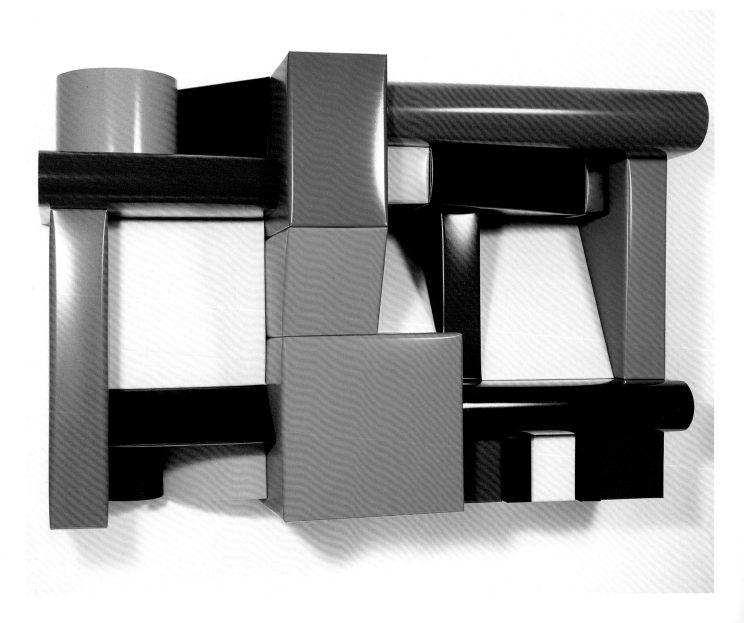

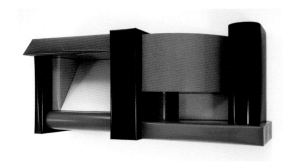

WE'LL ALL BE DEAD SOON 1986 [17]
(MULTI - COLOURED II)
Cellulose paint on steel
90 x 200 x 65 (35 ³/₈ x 78 ³/₄ x 25 ⁵/₈)
Private Collection

GOING TECHNO

With the sculptures of 1985 Opie was simplifying and refining his formal repertoire, and in time, the figurative element painted over the steel came to matter less. Perhaps inevitably, Opie came to focus on making purely abstract sculptures, combinations of geometric shapes – rectangles, cylinders and curving planes – spray-painted in bright, pure colours. Many critics were surprised by this apparent change of tack. Gone were the quirky, hand-painted representations, and in their place were these bold but impenetrable forms sealed in a smooth coat of cellulose lacquer. It would be wrong to think of these new works as non-representational, however, since it is impossible to describe them without drawing out a number of references.

Their seamless finish gave them an industrial or mass-produced quality, and they could have been made from moulded plastic or stretched PVC. Most were attached to the wall and could therefore be read as paintings, but they were three-dimensional, projecting into space and articulating abstract volumes. Opie said, 'The take-off point is still the question what is a picture and what is a sculpture, and how you can make something that isn't either but talks about both?'[8] This recalls the Minimalist ethos of Donald Judd, who, when writing on 'Specific Objects' in 1965, described something that was neither a painting nor a sculpture, but occupied an intermediate (although supposedly superior) position. The connection is important: the Minimalists' espousal of simple geometric abstraction and their rejection of handicraft in favour of industrial materials and methods of production obviously had resonance for Opie. Reacting against the hand-made aesthetic of his earlier work, he was searching for a new seriousness, and found this in the formal language of geometric abstraction.

Of course, to regard this new work as a straight extension of the conventions of Minimalism would be wrong; abstract art in the late 1980s was weighed down by other readings. Opie admitted, 'My frustration with abstraction was that it no longer looked simply abstract. What it looked like was "abstract art". Abstraction had become another "thing".' This attitude had found fuller expression in the ideas of the theorist Jean Baudrillard. Baudrillard had already popularised the view that originality in art was no longer possible, that there were only copies of copies or representations of representations, and no 'real' to which they might refer. Contemporary society was composed of surfaces and signs. Art reflected this, not least the work of a group of New York based artists who came together under the epithet 'Neo-Geo' and whose strategy was to simulate past styles of abstract art, treating modernist abstract tradition rather like a store of 'ready-mades' into which to dip. Opie recalls:

Art at the beginning of the 1980s had had an exuberance: all hand-made, hand-painted, and physically quite explosive. But this was replaced by something much tougher, hard-edged and professional-looking. I saw it with artists like Peter Halley, Ashley Bickerton and Gerwald Rockenschaub and what was called 'Neo-Geo', and I was attracted to this.

Having accepted that abstract art could not be read in purely formal terms and could not be viewed without suspicion, Opie added another layer of meaning to his scultpures by adopting ominous titles culled from recent newspaper headlines. They added intrigue: *Thousands Protest, Hundreds Arrested, Hospital Workers Return to Work, Stock Market*. It seemed disingenuous when Opie explained that the titles arose naturally because his working drawings were often made on newspaper pages. By using

SOVIET FROST 1986 [18]
Cellulose paint on steel
90 x 140 x 90 (35 $^3/_8$ x 55 $^1/_8$ x 35 $^3/_8$)
Private Collection, London

SPIES 1986 [19]
Cellulose paint on steel
90 x 90 x 105 (35 3/8 x 35 3/8 x 41 3/8)
Richard Deacon, London

CEASEFIRE 1986 [20]
Cellulose paint on steel
90 x 175 x 90 (35 $\frac{3}{8}$ x 68 $\frac{7}{8}$ x 35 $\frac{3}{8}$)
Saatchi Collection, London

UNTITLED 1987 [21]
Photo collage
132 x 272 (52 x 107 ⅛)
Lisson Gallery, London

phrases that were already in circulation, Opie reassured the viewer with something familiar and everyday: 'I needed a title that balanced the work. The work is quite closed and inaccessible, but the title is more everyday, more of this world. I was looking to ground them in a dull reality.' There were occasional connections between title and object. For example, *Soviet Frost* 1986 is a chilling white relief, whilst *Spies* 1986 is vibrant red – the titles making symbolic allusion to specific colours. But more often than not, there was no link between the work and the title it was given.

Their appearance is perplexing. Works such as *Soviet Frost* seem to carry connotations of architectural details or machine parts. The polychrome abstracts like *Postal Staff Return to Work* 1986 are more difficult to read: a joyous clamour of colours encases simple forms, suggestive of children's coloured building blocks. Lynne Cooke highlighted the difficulty of apprehending their actual forms:

Their compositions are so complex that they must be read as interconnecting elements rather than as single, integral units. In those with a glossy finish, in particular, reflections from one spray-painted surface onto another preclude any easy reading of the underlying forms, and various viewpoints are required to sort out the relationships between the individual parts. In a similar way the interplay between the polychrome surfaces undermines confidence in the fixity of solid form.[9]

Cooke saw how the works allude to a space behind or within, and concluded that the suggestion of hidden interiors is as intriguing as the exterior surfaces are intangible. In Opie's next body of work this emphasis on contained spaces, surface and depth was expanded.

Undecidable Objects

Opie's abstracts were simple but mysterious, alluding to the everyday but eluding it, highlighting the gap between perception and recognition. The sculptures that he began to make between 1987 and 1989 developed this. Such was their resemblance to commercial appliances and furniture that they barely escaped categorisation as 'refrigerators', 'air vents', 'shelving units' or 'storage cabinets', but none were functional as such. Michael Newman highlighted their ambiguities by calling them 'undecidable objects' when writing in the catalogue for Opie's solo show at the Lisson Gallery in 1988. He also rightly noted their connection with Minimalism – its materials and formal language. Referring back to Baudrillard's theories, these objects could aptly figure as 'simulacra' – copies without a definite model in the real world.

The impetus to experiment with other materials and processes had arisen for various reasons. Opie felt he had now exhausted the possibilities of working in steel, and a bout of ill health forced him to give up welding. He began to think about the opportunities offered by other materials with industrial associations, like aluminium and PVC. Also, and significantly, he found a larger studio and thus had more space in which to experiment. That his new studio was located in an area of East London with a history of furniture-making also meant that new source materials were close at hand.

Opie was also thinking more about how his work related to the space in which it was installed. This was no doubt partly due to having participated in a string of exhibitions in recent years. Moreover, at around this time a number of artists had come to focus on the relationship of their work to the gallery environment, and had begun to produce objects that resembled

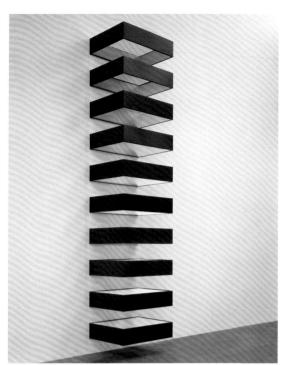

Donald Judd
UNTITLED 1990 [22]
Blue anodised aluminium and clear
Plexiglas
10 units: 23 x 101.6 x 78.7
(9¹/₈ x 40 x 31) each
Tate. Presented by the American
Fund for the Tate Gallery 2002

architectural features. The furniture-sculpture of Richard Artschwager was designed to mimic and merge with the utilitarian props of its surroundings. Other artists working in this way included Ashley Bickerton, Grenville Davey and Robert Gober. Their stylised evocations of standard items deprived of their expected function clearly ties in with Opie's project, although his own objects had a particular austerity.

Made in a range of shapes and sizes, attached to the wall and freestanding, his 'undecidable objects' both defined and merged with the pristine, white-walled gallery environment. Most Minimalist artworks were determined by their occupation of space and their presence as physical objects. It is hard not to compare Opie's units, crafted from aluminium and stainless steel, arranged in series, cantilevered to the wall or standing squarely on the floor, to Judd's 'boxes'. Opie acknowledges the connection:

Judd's boxes are beautifully made and beautiful as objects, and they are very purposeful. They are there to create and articulate space. There is a function and a purpose, and this was what I was looking for.

There is also a suggestion of Robert Morris's columns or 'slabs' of grey plywood, their size commensurate with that of the viewer. These works by Morris were visually minimal but powerful in a spatial sense, as is the case with Opie's objects.

The inert forms of such Minimalist sculpture made viewers more aware of their environment and their physical position within it; and Opie's objects also place the premium on physical engagement. With their highly reflective surfaces and polished metal interiors they relate to human scale and acknowledge human presence. We are confronted with multiple views – of us and the space around us. The units that resemble refrigerators and cabinets capture our reflection and trap it behind glass, behind matt-brushed aluminium and polished stainless steel. But they are sealed off from us and therefore negate both our presence and any possible use. Their interiors are either too shallow or so reflective that the interior becomes just another exterior. *J. 1987*, for example, resembles a shelving unit or display case: a series of gleaming white shallow shelves contained within a rectangle of aluminium and stainless steel and protected by a sheet of glass. The sturdy construction has a certain authority, but the shelves are too shallow to serve a purpose and the reflective surfaces turn everything back on us. The vents or slats that are fixed to the wall (like *H. 1987*, a solid rectangular structure attached close to floor level) also imply a space behind, but their grilles exclude the viewer. They do not facilitate the free flow of air, and if anything they add to the atmosphere of breathlessness.

The Minimalist object was perceived as not so very different from an everyday object, but it did not represent or refer to anything else directly lest its value be derived from its illusionistic likeness to that thing. But Opie's objects embody the idea that representations and references are inescapable in contemporary reality. He makes the most of it, suggesting that his art objects could have everyday use in a different context. Michael Newman wrote:

In an office or showroom the objects might be identified as, respectively, air conditioning/heating vents, display cabinets and refrigerators. The first are concerned with the artificial control of the environment, the second with the protection and display of objects, and the third with preservation. The 'vents' might be typically found in a corporate office, the 'cabinets' in shops, pharmacies and laboratories, and the refrigerators in supermarkets and frozen goods suppliers.[10]

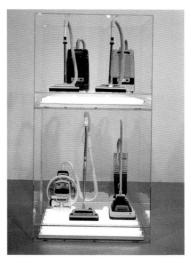

Jeff Koons
NEW HOOVER QUADRAFLEX, NEW
HOOVER CONVERTIBLE, NEW HOOVER
DIMENSION 900, NEW HOOVER
DIMENSION 1000 1981–6 [23]
Hoover vacuum cleaners, Plexiglass
and fluorescent lights
249 x 133 x 70.5 (98 x 52 $^1/_2$ x 27 $^3/_4$)
Collection of Lewis and Susan
Manilow

Opie's objects are simulations of functional objects but never exact copies. They incorporate features that we might associate with familiar domestic appliances but never quite enough. This is art in camouflage. It is both reassuring (in the sense that we recognise aspects of it) but also full of doubt and uncertainty. The titles are reductive in the extreme: a shallow wall-mounted display case is simply called *X.*, while two small square stainless-steel vents mounted high on the wall are titled *C.* This device appears to cement the conflation of high art and product design since the letters of the alphabet and numerals might allude to the simple titles of Minimalist sculpture as much as the coded identities of self-assembly furniture.

Opie explained his strategy: *It's important that you recognise where these works come from and that you feel quite normal about them... As soon as you don't then that becomes the entire issue and trying to work out what it is becomes the artwork. It seems important to find something in the world for the work to be like even though I'm not particularly conscious of or interested in what it is.*

His aim was to make us engage with the work through a functional type of looking, like reading. He used many devices to keep this framework intact. The works were often exhibited accompanied by preliminary drawings reminiscent of the kind of graphics and diagrams used to assist the home assembly of various prefabricated units of furniture. For the Kohji Ogura Gallery in Nagoya, he also produced a catalogue in the style of a trade brochure, within which photographs of the objects appear with their shadows removed on colour-coded pages.

Opie's subterfuge is easily exposed, however, since on close inspection we realise that his objects have no function. The illusion quickly collapses (as with those early painted metal sculptures). There is a further bluff, too: although these pieces look factory made

(another link back to Minimalism and the earlier abstracts) each has been meticulously crafted by the artist's hand. At every turn, we simply cannot get the full measure of the effort and the intention embodied by these objects.

Above and beyond the references already mentioned, there is another connection in both appearance and mood to the contemporaneous 'commodity' sculpture of American artists like Haim Steinbach and Jeff Koons. Koons's fluorescent-lit vacuum cleaners sealed in pristine Plexiglass containers are particularly relevant. Both Koons and Opie are dealing in postmodern mausoleums, but Opie's objects are mock ready-mades. As Michael Newman concludes, they 'presume the history of the ready-made, but they are not ready-mades, they presume the history of abstract sculpture and Minimal specific objects, but they are not abstract sculptures or Minimal objects within the terms of those types'.[11] We do not know whether to think of Opie's objects asMinimalist artwork or fridge-freezer, and the fact that we are confronting this play of references in an art gallery also makes us think more about the context: is the gallery a showroom, and the art object a commodity? In collapsing the worlds of high abstraction and product design, Opie invites us to examine how we relate to and discriminate between these worlds.

The *Night Lights*, fabricated in 1989, made an impressive conclusion to this body of work. They were freestanding, rectangular structures – larger than the earlier cabinets – and fitted with concealed fluorescent lights, thus invoking the work of another artist associated with Minimalism: Dan Flavin. Like many of Flavin's installations, they emitted softly glowing light that punctuated and animated the gallery space, creating a play of shadows and light across intervening spaces or corners. Opie worked on

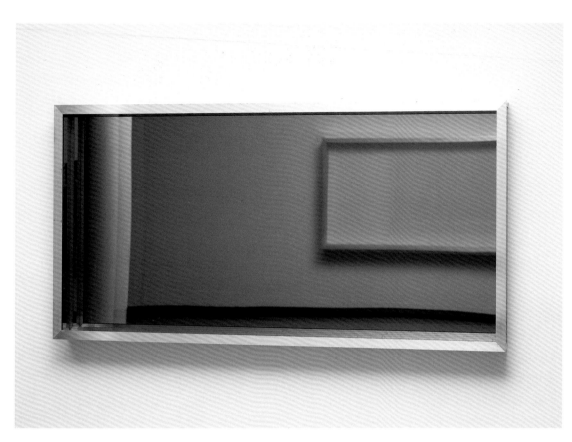

P. 1988 [24]
Glass, aluminium, stainless steel,
foam, PVC, wood
127 x 250 x 22 (50 x 98 $\frac{1}{2}$ x 8 $\frac{5}{8}$)
Private Collection, Cologne

JULIAN OPIE SOLO SHOW [25]
Installation, Lisson Gallery, London
1988

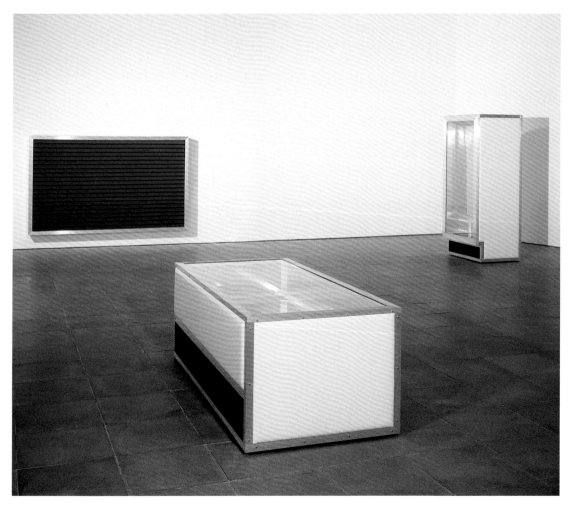

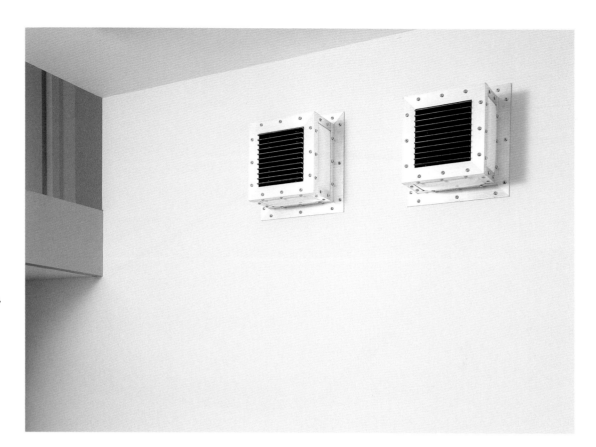

C. 1987 [26]
Aluminium, stainless steel, foam,
PVC, wood
2 parts: 31 x 31 x 14.5
(12 $^{1}/_{4}$ x 12 $^{1}/_{4}$ x 5 $^{3}/_{4}$) each
Jean Pigozzi, New York

J. 1987 [27]
Glass, aluminium, stainless steel,
foam, PVC, wood
127 x 217 x 27 (50 x 50 x 10 $^{5}/_{8}$)
Saatchi Collection, London

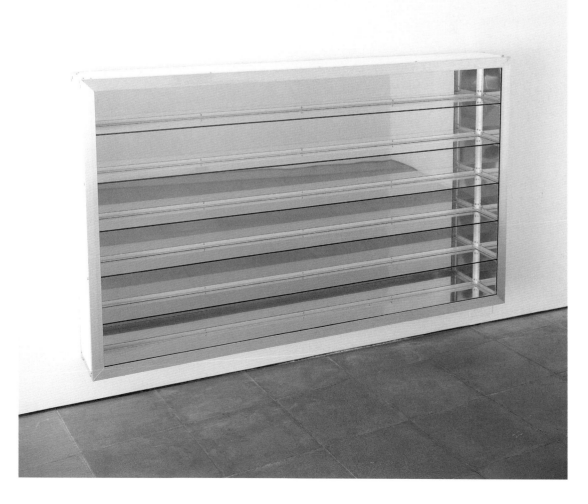

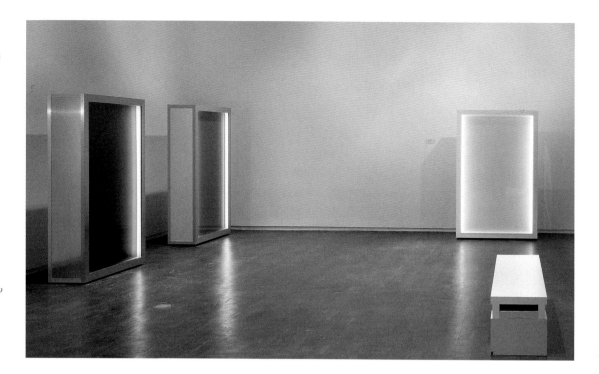

several simultaneously, fabricating up to fifteen over a period of about eighteen months. They could be shown individually but were more effective when installed in groups, taking up an entire room at Newport Harbor Art Museum in the exhibition *OBJECTives* in 1990.

In the accompanying catalogue, Kenneth Baker wrote that the *Night Lights* would neither sit easily in 'workaday civic life' nor find an entirely fitting home in the museum or gallery, but would 'vibrate with echoes of both'. The works also literally vibrated – with the hum from fans that were fitted to enhance their affinity to utilitarian objects. Contrasting with their blank façades, their reverse sides were adorned with intricate details like cords, grates, switches and plugs, added to give the impression that they had internal workings and a function. Baker noted how they 'resemble giant light boxes of the sort used to view slides or X-ray transparencies' but added: 'The sense that they are devices for viewing something else jostles with one's assumption that they are artistic ends in themselves.'[12] The truth was that despite their apparent purposefulness, the softly pulsating bands of light illuminated nothing, and the interiors were too shallow to contain anything. Opie acknowledges: 'You're looking at something that makes so much effort to be there but in the end seems to lack the thing that might explain *why* it's there.'

The structures made by Opie between 1987 and 1990, culminating with *Night Lights*, could be classified as pseudo-prototypes. They occupy a middle ground between art-work and functional object. They are empty but full of intent and meaning, raising questions about realism, about how we recognise and receive objects. They make us aware of the complexities of space, context and location, and their ambiguity triggers a powerful response.

The Night Lights *came out of working on the cabinets and display units. I saw how they already made the most they possibly could out of their materials, and their shape, but they were lit from outside, I wasn't controlling that. I'd seen these backlit signs in garages and shops; the glowing colours at night were so seductive. So with these things in mind I set about putting back-lighting into the boxes. They would look more purposeful then. But still what you get is muted, quiet. I brought the inside back wall of the box up close to the front so that there was no longer a space to look into. What you get is just a ghostly reflection of yourself and the space behind you; it's all thrown back at you. These works are much more painterly.*

The Night Lights *were drawn from a synthesis of things – advertising signs, bus stops, shop fronts – that I found in the public world. I photographed lots of billboards. Their structure fascinated me: take out the message and what have you got? Sometimes you see an empty billboard in the middle of London, between advertising campaigns; it's quite lovely looking. And I also drove a lot, through America, passing through petrol stations, airports, all of which shared this temporary quality, this glossy veneer that didn't have to last, that could be wiped clean. I found this to be neutral, romantic – I was drawn to it.*

I felt Night Lights *had this narrative quality about the world, a certain melancholy, and a low-key sense of drama, like the passages in a Raymond Chandler story where there's a sense of excitement although nothing much is actually happening. I was trying to evoke a kind of bored but expectant atmosphere – like a hospital corridor or an airport lounge. I wanted my work to have a more serious quality, something that reflected mortality. I saw the sealed spaces as offering escape – if perhaps a deathly refuge. Possibly this was related to having become ill myself, but it also came out of my frustration that my earlier work couldn't address such ideas and emotions. I also sensed a change of mood, not just in me, but more generally. This was the end of the 1980s; there was a sense of being more interested in the cool and the quiet than the wild excesses of the earlier 1980s where there was a more punky, florid, humour-based approach. So I began searching for a different language. I was trying to find more physical ways of using narrative.*

The Night Lights *look like empty vending machines. Lit up from inside, they have this quality of being reassuring but also technical, modern. They were hard but human, and found in what could be quite a threatening, alien public place. So if you walk into a museum, the* Night Lights *might seem off-putting. They convey the 'disquiet of modern*

life' – you know, the idea that this tough modern world doesn't suit our soft bodies at all – but they were sort of homely too, like an open fridge at night.

The public arena is one of mistrust and distance. You must find a way to break that down and find intimacy with strangers, people who don't know you and won't trust you. Giving the Night Lights *a function was a way round this. We're so used to the idea in architecture that a functional building is more 'honest' than those that are designed. Making the* Night Lights *appear to have a very clear function would defuse the problems of acceptance, rejection, admiration that often make it difficult to look at an artwork.*

The Night Lights *make references in the real world: they could be machines, so the idea is, you can just look at them, but they also have a function. I think art objects can deal with these conflicting suggestions. You could look at them like you might look at a landscape, or the inside of a plug, and this might make for a more interesting type of looking, an inquisitive kind of looking, where you find beauty for yourself.*

One time I was exhibiting them in a gallery and I saw someone bend down, unplug one and come round to the front again to see if it had made any difference. I felt then that it had worked. I always put them close to the wall; you could peer round the backs, but not really get at them. I was playing with the fact that people were always touching things in galleries, so I was giving people something to do, and while you're doing that I've caught your attention.

I really enjoyed the planning and making of the backs of the Night Lights. *This allowed me to be inventive and to play, whereas the fronts were so restrained. A lot of work around that time was playing with this overblown sense of functionality. Ashley Bickerton's 'machines for collectors' were big and bold, but just more complicated nothingness.*

I called these works Night Lights *because it was perhaps the beginning of accepting a more psychological, or more autobiographical reading of my work. And after this the titles become more engaging again. But I also thought they needed a brand name. The titles would have to have the same industrial blank quality as the works themselves, and the code given to each does mean something: it describes the various materials and colours that make them. I could have called them 'Just Looking': they were about the simple act of looking. They were minimal, so the next group of work became maximal by comparison. By holding back in this way I think it allowed my next work to really burst out, and this resulted in much larger pieces. But this was only possible after I'd spent so long studying this* ABC *of representation and objectness.*

NIGHT LIGHT 23/3333CY [30]

Aluminium, glass, stainless steel, plastic,
wood, rubber, fluorescent light
188 x 124 x 43 (74 x 48 7/8 x 16 7/8)
Lisson Gallery, London

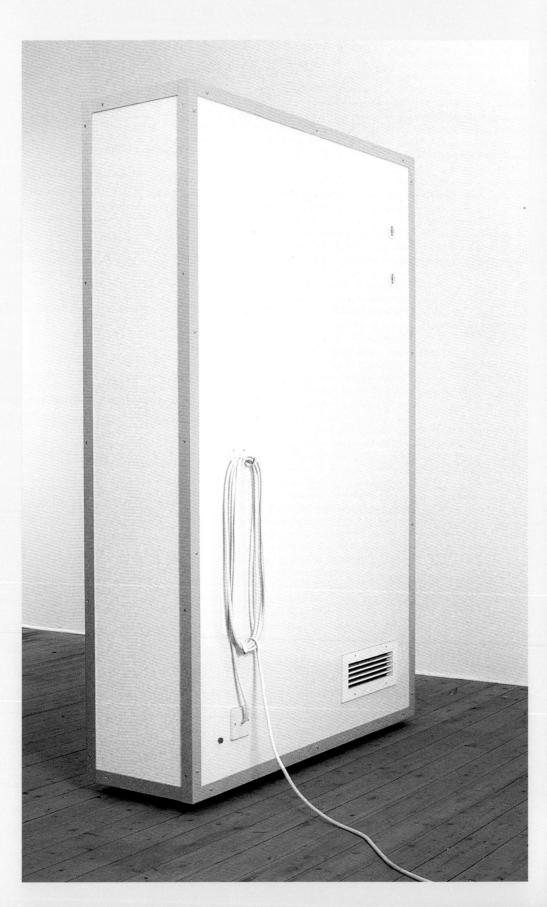

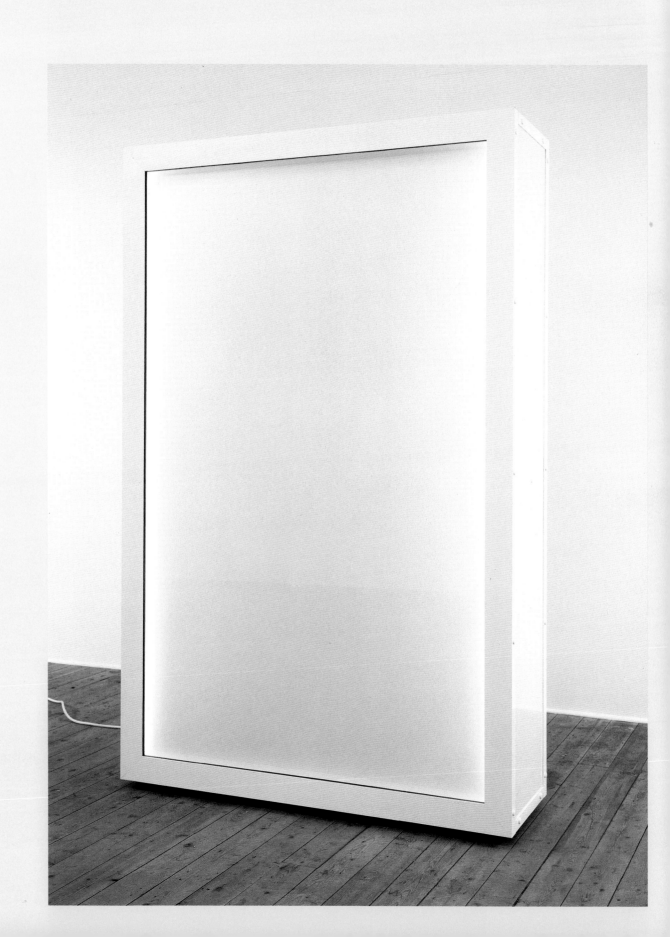

NIGHT LIGHT 19/1343GY 1989
[31]
Aluminium, glass, stainless steel, plastic,
wood, rubber, fluorescent light
187 x 123 x 45 (73 ⁵⁄₈ x 48 ³⁄₈ x 17 ³⁄₄)
Guiseppe Casagrande, Rome

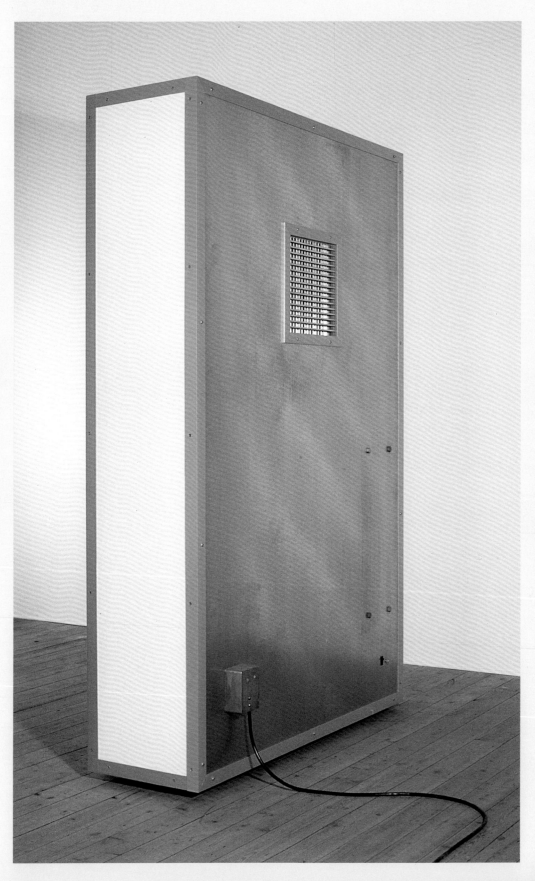

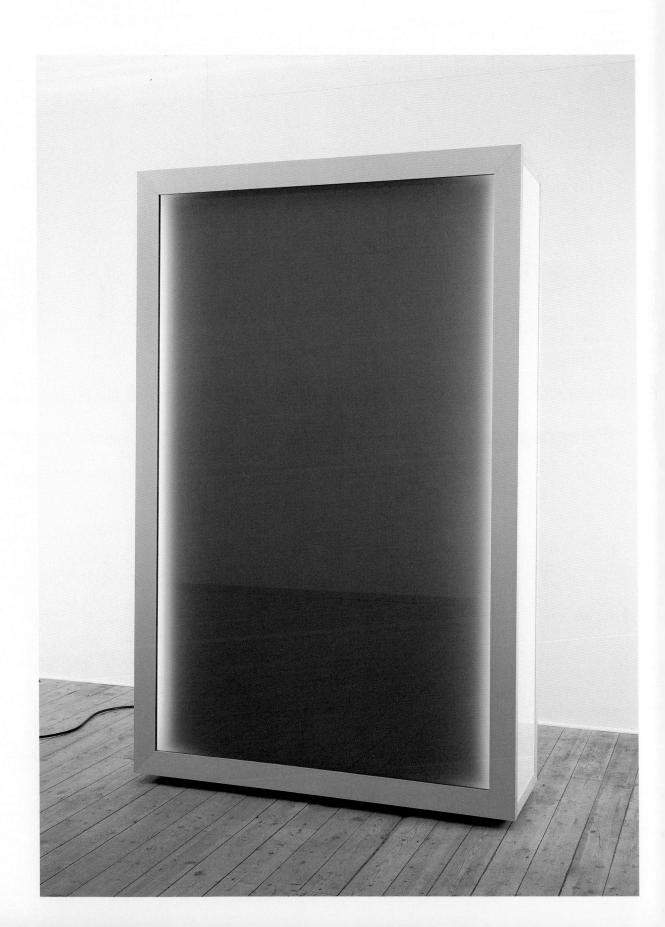

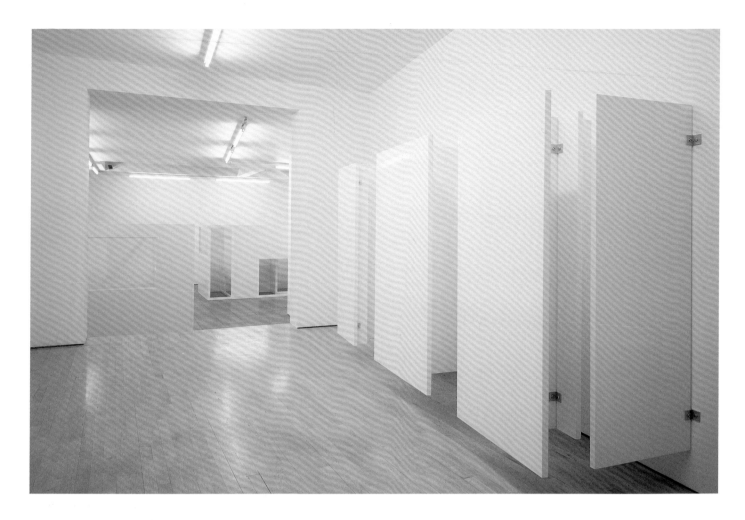
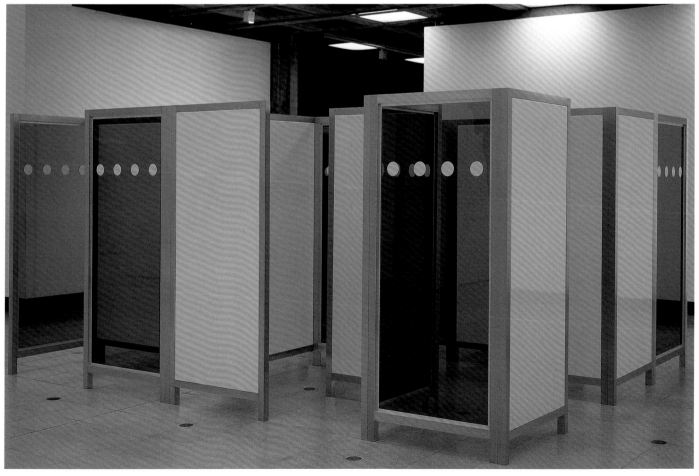

INSTALLATION, LISSON GALLERY,
LONDON 1990–1 [32]
foreground: NUSON 220 1991
background, left to right:
DEXTAN C17 1990 and HAYDEN CE16
1990

A 199/6 1989 [33]
Zintex, aluminium, tinted glass,
enamel
24 panels: 188 x 324 x 405
(74 x 127 $^5/_8$ x 159 $^5/_8$) each
Lisson Gallery, London

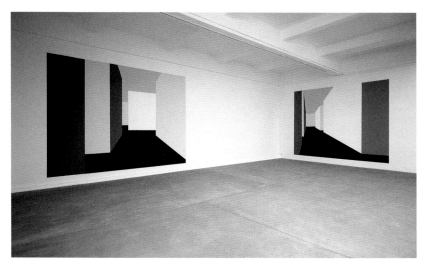

INSTALLATION, CHISENHALE
GALLERY, LONDON 1993 [34]
left: IMAGINE YOU ARE WALKING (1)
1993
right: IMAGINE YOU ARE WALKING (2)
1993
Emulsion paint
Dimensions variable

MACHINES FOR LOOKING

3

The objects that Opie made in the late 1980s and early 1990s were full of echoes of early modernism. But the references went beyond the world of art. Opie showed how the forms invented by artists of the modernist avant-garde had been adapted into the vernacular of our world. Thus, when we encounter these works we touch down in an everyday reality and think about urban environments, those fabricated spaces – or 'non-places' – that are both routine and pervasive. Following on from the *Night Lights*, Opie started making more complex sculptural installations – partitions, booths, modular units – all of which closely inter-relate and could figure as components of an imaginary space to be inhabited by the white-collar worker.

Partitions

In 1989 Opie built several partitioned works, exploring the complexities of three-dimensional space, the experience of which implicitly includes action and the body. These interconnecting panels of glass and aluminium divided up space into rigid channels. In a sense, he was linking together the mute façades of the *Night Lights*. Within these structures, the materials of Minimalism and the rational, hard-edged geometry of modernist architecture come together. Architecture defines boundaries, between inside and outside, between what is closed off and what is accessible. The architects of modernism promoted functional design, unlimited visual access, purity, clarity, and gave form to an aesthetic that now pervades the urban environment. However, in the 1970s many artists reacted against this and undertook a critique of modernism and its impact on the social fabric. Prominent amongst them was Dan Graham, whose pavilions of transparent and semi-mirrored glass mimic the experience of surveillance,

insecurity and denial that became symptomatic of modernist design.

Opie obviously shared Graham's interest in fabricated environments, and the dual sensations of accessibility and exclusion that they generate. Entering one of Opie's partition structures we experience a certain visual insecurity through being caught between two glass walls, looking outwards, seeing the space beyond, but also being aware of ourselves reflected. Typically Opie incorporates references from a more mundane reality: his structures are as much MFI as modernist abstraction – utopian rationalism filtered through the blandness of a mass-produced, corporate style of furniture design. As such, they approximate the kind of dividers or partitions found in airport customs halls or in large, open-plan offices.

These partitions were a departure in the sense that, until this point, the function of Opie's fabricated objects had been fictitious. Here, for the first time, his sculpture fulfils our expectations – its role is to divide up space and direct our movement through it, and this it does. Indeed, the main visual interest in a partition like A 199/6 1989 comes through our interaction with it. As authoritarian structures they control our movement, and Opie admitted:

I'm interested in the feelings created by very functional spaces, where there's a sense of alienation involved in being obliged to give up your individuality. It's attractive to feel alienated – to experience loss of self – as long as one can see oneself doing it.

Thus the partitions acknowledge our desire as much as our need to relinquish responsibility in the public domain. Opie often argues that a sense of detachment is necessary, that we must distance ourselves from reality in order to see it clearly.

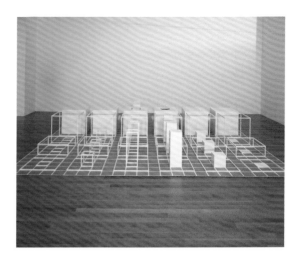

Sol LeWitt
SERIAL PROJECT NO.1 (ABCD) 1966
[35]
Baked enamel on aluminium
96 units overall
50.8 x 398.9 x 398.8 (20 x 163 x 163)
The Museum of Modern Art, New
York. Gift of Agnes Gund and
purchase (by exchange)

The idea of looking at things from a distance became more literal in the next group of works. Opie's partition works – wall-mounted arrangements of panels projecting into space but refusing the viewer access – would now place the premium on denial. The white enamelled screens of *Nusan 220* 1991, for example, make up a series of cramped, cubic spaces that neither reach the floor nor extend much above head height, offering only the illusion of privacy. We might think of the cubicles in public lavatories or telephone booths: private spaces in public places. But Opie's partitions would be ill-suited to occupation. We peer into them, trying to ascertain the sum of their parts, but the idea of entering them remains precisely that – an idea.

Houses and Shelves

Opie's partition works marked a moment of transition, and the shift into architecture as both motif and form is perhaps more resolved in his 'Houses'. These self-contained, part-glass, rectangular units share the industrial, mass-produced appearance of the 'undecidable objects'. *HA/45–1*, *Dextan C17* and *Hayden CE16*, all dating from 1990, resemble miniature portakabins or small office booths, each measuring approximately 3 x 2 metres, and relating to human scale.

If we consider these works as architectural prototypes, they contain references to classic examples of modernist architecture – Mies van der Rohe, Le Corbusier, De Stijl and their coded titles imply prefabs of some kind, so they could be variations of Le Corbusier's 'Mass Production Houses'. They can only be occupied imaginatively however. They have windows that are large enough to offer a full vista of the interior space but no doors to offer admittance. Opie excludes us, offering a pure

optical or intellectual experience – that of 'looking at' but not 'being in'. Opie's 'Houses' thus reiterate modernism's emphasis on transparency but serve no function and exclude us.

If we relate the *Houses* to sculpture, their cubic forms resemble to the work of Sol LeWitt. For LeWitt, the open cube represented the simplest, most neutral unit with which to work. His fascination with the cube was driven by an interest in serial forms and systems for generating them. Through grounding everything in a grid structure, LeWitt could focus on other concerns such as scale and space, the activation of the viewer's sense of surface, and questions of interiority and exteriority.

The repetition, variation and interchangeability of basic units within a whole was also becoming a guiding principle for Opie, not simply as an aesthetic effect but as an integral part of his working process. With the 'partitions' and 'Houses' he was exploring the multiple possibilities within a single concept. This becomes clear when considering the subsequent series of work, objects that echoed the formal arrangement of space found in the 'Houses' but offered a completely different reading by way of their re-orientation as wall-mounted units. Their domestic scale, their placement on the wall at a certain height and their perfunctory titles (*Shelf Unit A* or *B*) suggest pieces of furniture. The apparent irreverence of making a sculpture that looks like a shelving unit might also refer to the apparent irreverence of a shelving unit being adapted from the grid structures of high art in the first place. Opie was a canny observer of the manifold ways in which old ideas resurfaced in new contexts. He enjoyed playing with referentiality, the suggestion that his objects had a purpose and use in our everyday lives, and still wanted to distract attention from their art identity.

HA/45–11 1990 [36]
Wood and glass
198 x 289.5 x 208 (78 x 113 3/4 x 81 7/8)
Kunsthalle Bern 1991

IMAGINE YOU ARE CLIMBING 1992
[37]
Paint on wood
220 x 200 x 200 (86 5/8 x 78 3/4 x 78 3/4)
Lisson Gallery, London

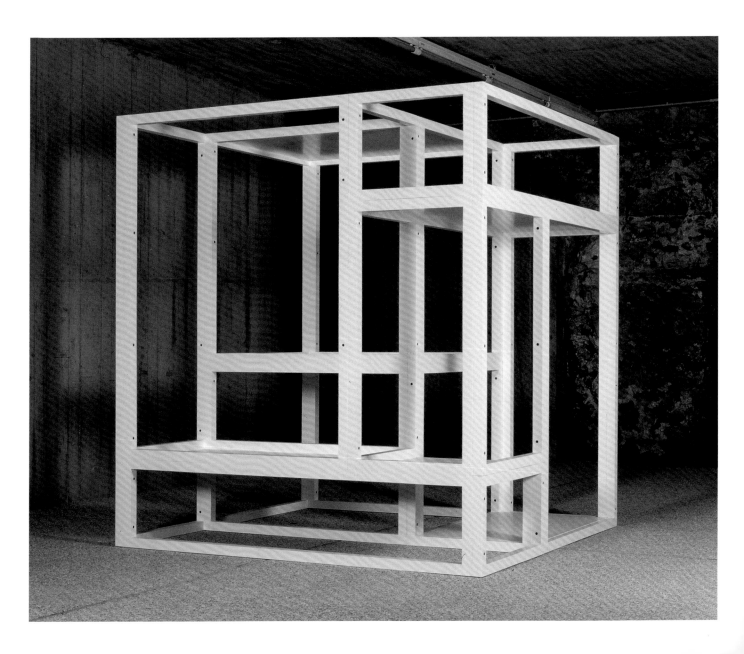

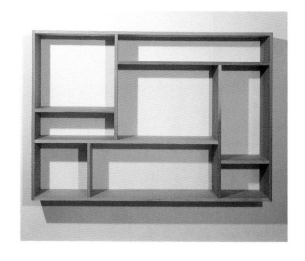

SHELF UNIT A 1991 [38]
Wood
141 x 207 x 30 (55 $^1/_2$ x 81 $^1/_2$ x 11 $^3/_4$)
Lisson Gallery, London

The titles invariably reinforce this – *A 199/6, HA/45–11, Shelf Unit B* suggest flat-packed furniture more than works of art. But Opie also began to adopt unusual titles for his works, titles that relay amazing facts and figures. Thus a large, freestanding shelf unit dating from 1991 is called *The Great Pyramid of Cheops contains enough stone to build a low wall around the whole of France*. This is a jump from the reassuring 'brand' names, the codes and classifications he had been using before. But in some sense the two types of title are not so different: both are open-ended, encouraging us to visualise something that is not always apparent.

It is fitting that at this point Opie also first asks us to 'imagine', with the work *Imagine you are climbing* of 1992. He would follow this with different works: *Imagine you are walking, Imagine you are driving, Imagine you are moving*. To invite us to 'imagine' is an evocative proposition. It literally means to form a mental image or concept, to picture for oneself, but it can also mean to suppose, to conceive, to ponder, to guess. We frequently associate it with child's play, and games of make-believe. In actuality *Imagine you are climbing* is a thin, plywood frame, a near-perfect cube, divided up into neat, right-angled sections in a further exploration of cubic forms. Opie is not suggesting that we take direct action, but merely encourages us to speculate on the work's potential use.

Blocks, Boxes, Columns

Having made works that explore, specifically or generally, the structure of urban space, it was perhaps appropriate that Opie would begin to consider how to represent the modern city as a whole. His sculptures of 1991 and 1992 conjure a series of abstracted, modular city-scapes.

The 'block' sculptures, as they have been called, are accretions of vast white boxes divided by narrow channels, as with *In order to cut glass it is necessary to score a line one molecule deep* 1991. The shapes of the individual blocks that make up the sculpture are difficult to gauge, and the channels between them are too narrow to enter. Only after repeatedly circumnavigating the work can we decipher the actual shapes of the outermost block (a continually shifting play of shadows adds to the confusion), and those on the inside remain mysterious. This sculpture was based on a plan of Turin, a city designed by Baron Hausmann in the nineteenth century. Hausmann's strategy of presenting the city as spectacle and commodity, full of unexpected vistas and improbably shaped corner buildings, is elegantly interpreted in these abstract forms.

The layout of a city such as Turin prefigures the modernist geometry of a city like New York. Working on the same scale but following this grid aesthetic, Opie produced coloured 'box' sculptures that are far more regular in structure: clear-cut geometric forms towering upwards, the regularity of their arrangement suggesting the archetypal modernist city plan. These sculptures also recall the reductivist abstraction of De Stijl in layout and colour, having white exteriors but colour-coded interior walls. From a distance, *It is believed that some dinosaurs could run faster than a cheetah* 1991 looks like a rectangular monolith, but by moving around it various narrow, intersecting passages become visible. The colours of the inside walls could be for orientation, allowing us to make a mental map of the sculpture. Ulrich Loock called these box sculptures 'machines for making pictures'[13] since the height of the columns means that the view through each channel can be read as a flat picture plane of different coloured bands.

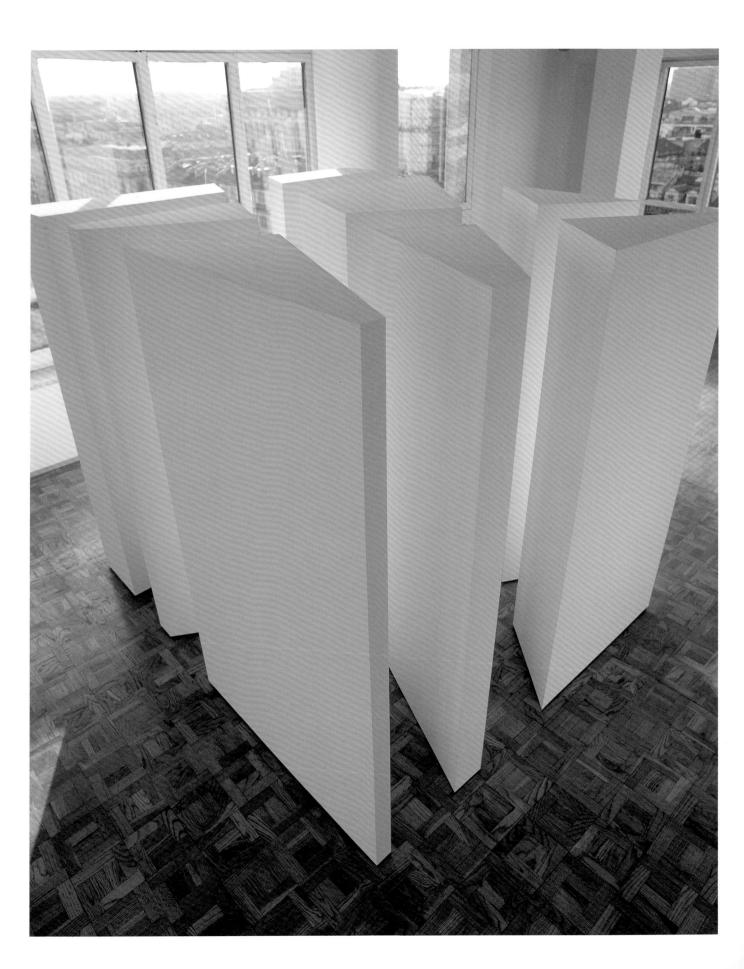

IN ORDER TO CUT GLASS IT IS
NECCESSARY TO SCORE A LINE ONE
MOLECULE DEEP 1 1991 [39]
Water-based paint on wood
196 x 240 x 200 (77 7/8 x 94 1/2 x 78 3/4)
Private Collection, Turin

IT IS BELIEVED THAT SOME
DINOSAURS COULD RUN FASTER
THAN A CHEETAH 1991 [40]
Water-based paint on wood
200 x 200 x 280 (78 3/4 x 78 3/4 x 110 1/4)
Tate

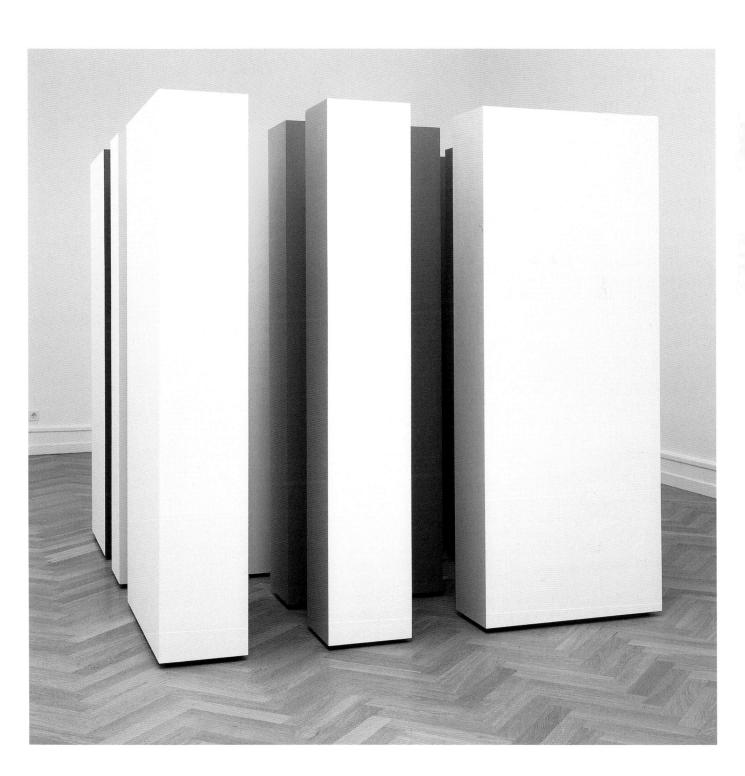

PAINTING OF IN ORDER TO CUT
GLASS IT IS NECCESSARY TO SCORE A
LINE ONE MOLECULE DEEP 1991 [41]
Aluminium, glass, acrylic on wood
89 x 127 x 4 (35 x 50 x 1 5/8)
Private Collection

Opie also made a series of 'column' sculptures, which he saw as the inverted versions of the 'block' sculptures. Their exact shape is as difficult to grasp since they far exceed human scale and some are colour-coded so as to disguise their external contours. They were made out of what appeared to be architectural moulding strips. Opie grouped them together to create towering structures that dominate any space they occupy. Whilst approximating an everyday architectural feature they also allude to the more grandiose Classical column. Their long and complex titles – *There are 1800 electrical storms in the earth's atmosphere at any one time* 1991 – conjure a mood of questioning wonderment. The fact that so many of these titles allude to speed and distance (consider also: *The average speed of a car in London is slower than that of equestrian traffic at the turn of the century*) keeps ideas of modernity, transport and travel at the fore.

Picturing Space

Opie had always made and exhibited drawings of his sculptures – graphic illustrations that are more like practical guides to show how his works were made. In 1991 he began making paintings of his sculptures, as in *Painting of it is believed that some dinosaurs could run faster than a cheetah.* These look as if they could have been designed on computer: reduced in scale and rotated to offer an aerial perspective, they are like miniature maps to provide a means to navigate. Their functional frames and reflective surfaces reinforce the sense that they are not pictures to be studied in any depth (indeed, Opie likens their structure to the shiny, impenetrable façades of the *Night Lights*). He used the paintings to explain the sculptures, and in time the process of engaging through explaining

became the focus. It was not just about the paintings, nor just about the sculpture, but their combined effect.

With *Imagine you can order these* (dating from 1992), Opie explored this relationship between three-dimensional sculpture and two-dimensional picture plane, between actual space and depicted space, whilst extending his interest in modular systems. This work was first conceived as a sculpture, consisting of a group of twelve brightly coloured rectangular box shapes, resembling out-sized children's building blocks. He made seven of these sculptures and devised a series of layouts for them, disposing them as though they were office buildings making up a city centre.

Opie also made paintings offering aerial views of each layout. The paintings show all the configurations proposed, differentiated by brightly colour-coded backgrounds. Within this single work, Opie attempted to explore every available option. Previously he had played out all the variables in a given artwork by executing a number of different pieces, but here he explores and includes all the options in one work.

Imagine you are walking followed shortly after this and is an exhaustive enquiry into serial forms focusing purely on the two-dimensional. Opie made eighteen paintings of what was basically the same view: an empty passageway. Endlessly different yet endlessly similar, these views could be stills from a virtual reality 'walk-through' of a block sculpture: blank walls receding in one-point perspective, a limited palette of pale greys and blues. Significantly there was no sculptural equivalent to *Imagine you are walking*. It was based on reality, or the artist's recollection of it – the subject being the streets of London's East End:

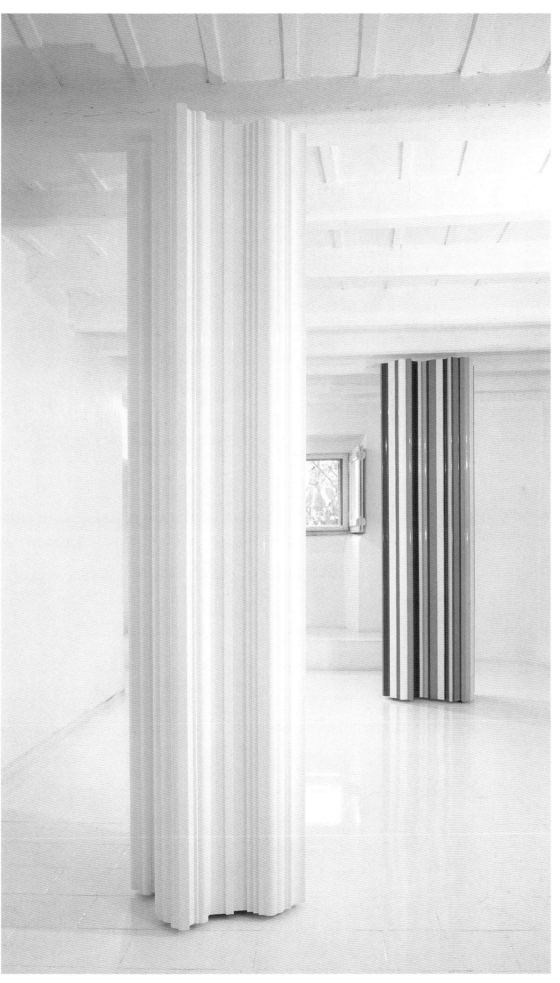

INSTALLATION, PRIMO PIANO,
ROME 1991 [42]
foreground: THERE ARE 1800
ELECTRICAL STORMS IN THE EARTH'S
ATMOSPHERE AT ANY ONE TIME 1991
230 x 55 x 61 (90 $\frac{1}{2}$ x 21 $\frac{5}{8}$ x 24)
Collection Lembachhaus Stadische,
Munich
background: THE AVERAGE SPEED OF
A CAR IN LONDON IS SLOWER THAN
THAT OF EQUESTRIAN TRAFFIC AT
THE TURN OF THE CENTURY 1991
230 x 55 x 61 (90 $\frac{1}{2}$ x 21 $\frac{5}{8}$ x 24)
Collection the artist

overleaf: IMAGINE YOU CAN ORDER
THESE (SCULPTURE I & II) 1994 [43]
Fibreglass
12 units: dimensions variable
Caldic Collection, Rotterdam

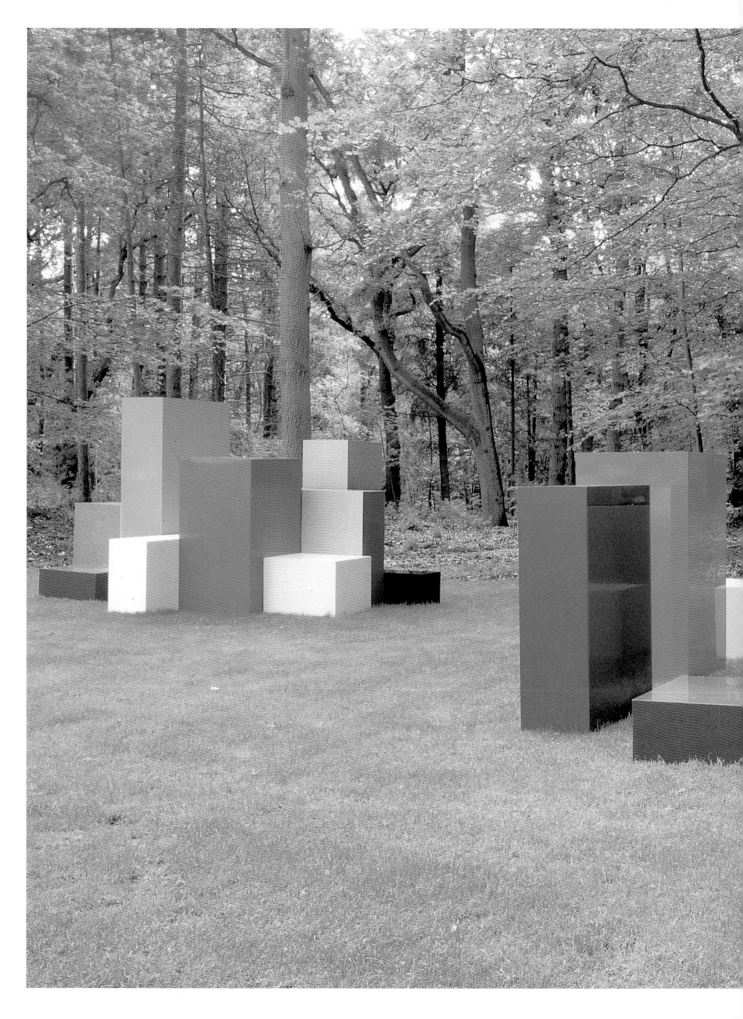

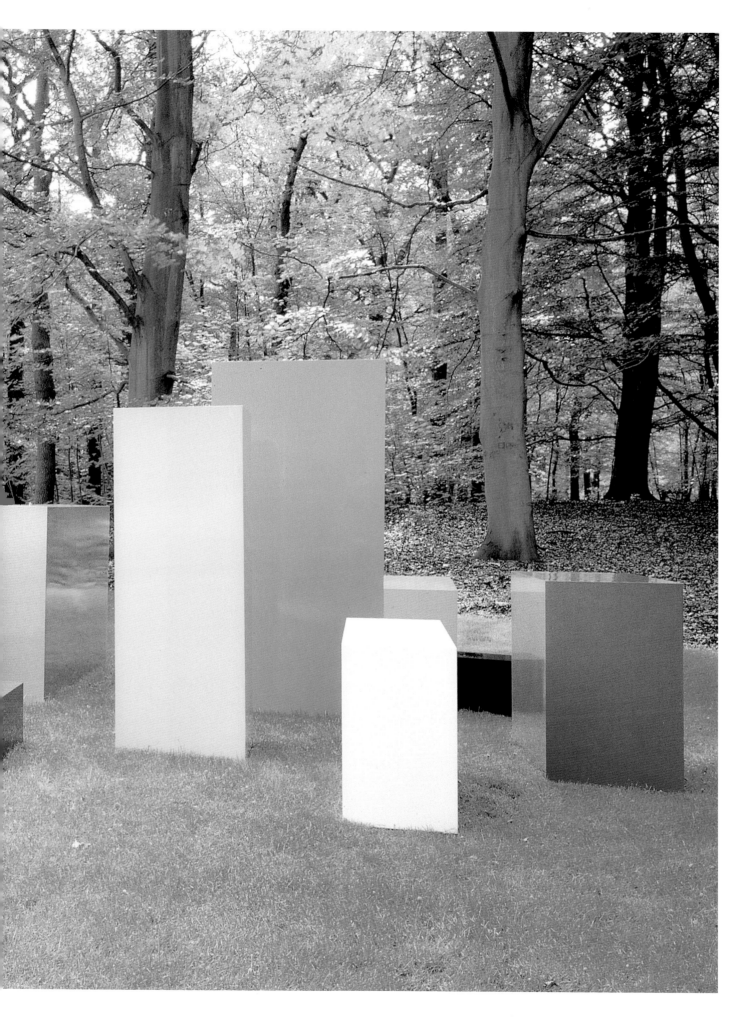

IMAGINE YOU CAN ORDER THESE (5)
1992 [44]
Acrylic on wood, aluminium, glass
97 x 128 x 6 (38 $\frac{1}{4}$ x 50 $\frac{3}{8}$ x 2 $\frac{3}{8}$)
Private Collection, London

IMAGINE YOU CAN ORDER THESE (3)
1992 [45]
Acrylic on wood, aluminium, glass
77 x 92 x 6 (30 $\frac{1}{4}$ x 36 $\frac{1}{4}$ x 2 $\frac{3}{8}$)
Private Collection

IMAGINE YOU CAN ORDER THESE (6)
1992 [46]
Acrylic on wood, aluminium, glass
97 x 128 x 6 (38 1/4 x 50 3/8 x 2 3/8)
Private Collection

IMAGINE YOU CAN ORDER THESE (4)
1992 [47]
Acrylic on wood, aluminium, glass
77 x 92 x 6 (30 1/4 x 36 1/4 x 2 3/8)
Collection of Dorothy Berwin,
London

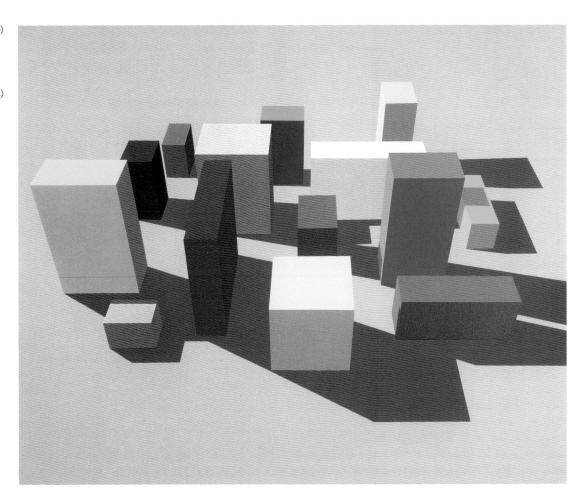

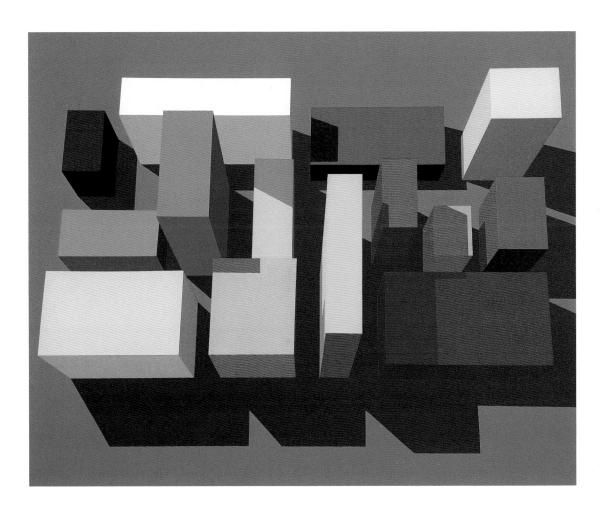

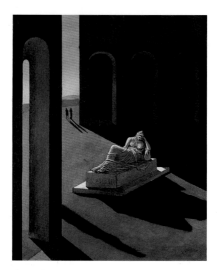

Giorgio de Chirico
MELANCONIA 1912 [48]
Oil on canvas
78.5 x 63.5 (30 7/8 x 25)
Estorick Collection, London

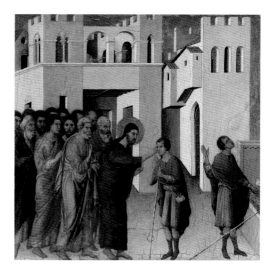

Duccio
JESUS OPENS THE EYES OF A MAN
BORN BLIND 1311 [49]
Tempera on wood
43.5 x 45 (17 1/8 x 17 3/4)
The National Gallery, London

I remember sitting in the studio after walking around the East End and mapping it out, drawing rectangles and triangles for buildings and corners. Then I put my pencil down on a particular point and tried to imagine where I was and what I would see – that was the first drawing for Imagine you are walking. *The city offered reality to me, so I didn't need to make a sculpture.*

The pared-down architecture and muted tonal range of the *Imagine you are walking* paintings recall the empty piazzas depicted by the metaphysical painter Giorgio de Chirico. De Chirico's depictions of shadowy, anonymous spaces have a hallucinatory quality – they are often deserted, like theatre sets waiting for the action to be projected onto them. Opie's empty spaces echo de Chirico's but have a more contemporaneous correspondence to computer-generated imagery. At this time, computer graphics employed a very basic two-dimensional form of simulated realism, a style that now seems very primitive. Opie saw in it a closeness to the simplicity of the architectural and spatial constructions found in late medieval and early Renaissance painting, in the work of artists such as Duccio or Cimabue, where a more narrative sense of space is created. The serial views of *Imagine you are walking* also suggest a kind of narrative. This gave Opie the idea of making an animated film, creating a 'walk-through' experience using computer technology. From this point onwards the computer assumed greater importance for him, informing his aesthetic choices as well as his practice, allowing him to develop his ideas in virtual space and leading to multiple manifestations of *Imagine you are driving.*

IMAGINE YOU ARE WALKING 1993 [50]
top: (10)
middle: (11)
bottom (12)
Digital drawings
25 × 33 (9 ⁷/₈ × 13)
Lisson Gallery, London/Private
Collections

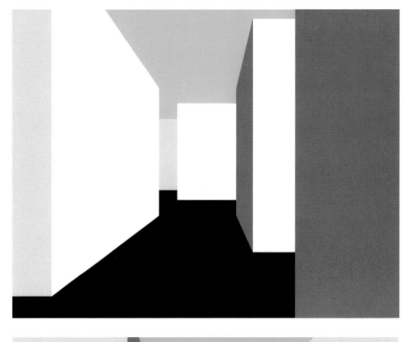

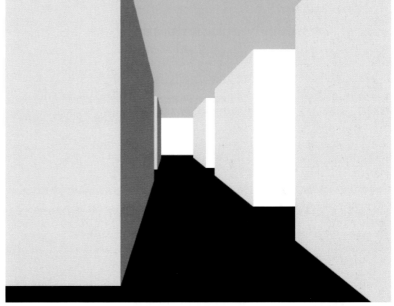

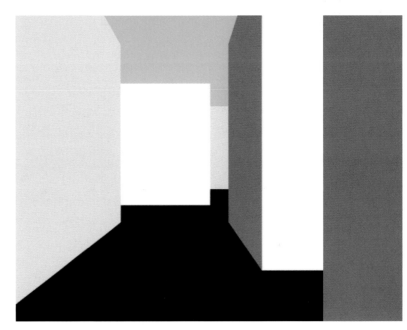

The experience of driving, so rooted in contemporary existence, would become a powerful metaphor for Opie. *Imagine you are driving* was the first of many works that adopted this narrative, the *Imagine . . .* of the title being an invitation to enter another world. It takes multiple forms: originally conceived as a series of paintings, it also exists as a computer animation and as a group of sculptures. They were first shown at Opie's solo exhibition at the Hayward Gallery in 1994. Later, he made a series of large-scale vinyl paintings.

I think it was in 1991: I'd bought a Citroen CX and gone to Europe, ostensibly to go and check out some galleries but really just to escape, and part of that escape was driving. I took my camera with me, thinking I'd photograph buildings – which was my interest at the time – but I found that it was too stressful to look out for them, to have to make decisions about when to stop and what to photograph. So I didn't stop, but just took photographs from the driving seat, aiming straight ahead. I came back with a lot of material and started drawing. I began to see how the view of the road ahead could be an endless, infinite picture: an endless number of views, an infinite number of possibilities.

Imagine you are driving was a series of paintings that showed an apparently time-based sequence of views of a three-lane motorway. As the view is from the driver's perspective, Opie asks us to place ourselves in the work. Though inspired by his travels across Europe, these images were actually based on photographs of the M40. However, the road depicted is not specific; detail has been edited out and the focus is on the pristine tarmac, the white road markings and the clear sky. It is like a frozen screen from a computer racing game.

I had to knock out a lot of detail to find the right image. Detail slowed everything down. I wanted to make the image more real, and when you're driving at speed, 90 per cent of what you're seeing is just sky and road. The only thing in focus is the road. And you're so low down you'll only see this tiny strip of green in between.

Like the architecture of the post-war period, motorways encapsulated an ideal of efficiency, a promise of the future. But the initial excitement has long since waned. Motorways generate feelings of alienation: the road becomes a non-place where personal choices are abandoned in order to conform to certain rules, the monotony of driving subsuming the individual. For the critic James Roberts, these paintings were disconcertingly accurate in terms of the experience they were representing:

INSTALLATION, HAYWARD GALLERY,
LONDON 1994 [51]
foreground: IMAGINE YOU ARE DRIVING
(SCUPTURE 1, 2, 3) 1993
background: IMAGINE YOU ARE DRIVING
(PAINTINGS) 1993
far wall: IMAGINE YOU ARE DRIVING
(COMPUTER FILM) 1993

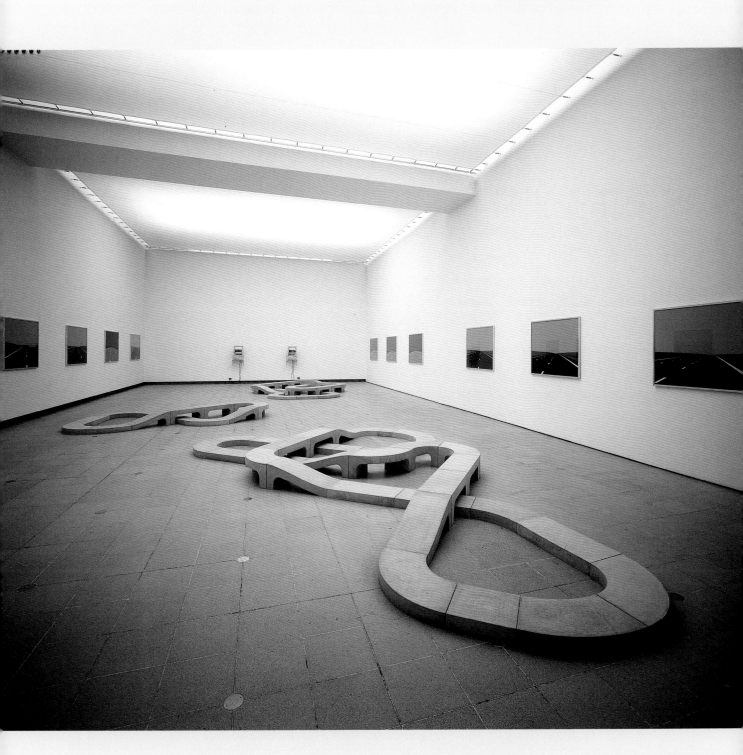

[They] are a strange mixture of real and simulated experience: the blandness of the endless grass verges and the incessant approach of white lines are all too close to the tedium of motorway driving, a tedium punctuated only by the occasional incident of bridges and intersections that loom into view from a speck on the horizon with an unerring sense of predictability. Yet the perfection and simplicity of the world they describe is closer to the simulated world of computer games. Driving itself is close to being a simulation: the exaggerated perspective of the motorway vista seen from the driving seat and the floating sensation which takes hold at high speed, make it seem that the car is standing still as the scenery passes by.[14]

Opie comments:

You only experience a motorway by driving on it, and the experience is kind of numbing – you leave reality, the state of speed being the negation of reality. I wanted to create this effect, the numbing shift out of reality. It was something I tried to achieve with the earlier objects, but people found it difficult to understand them: they wondered about the functionality, the references. Here, you stare at a highly reflective surface – glass and an aluminium frame – just like before, but you see an image behind it: the open road. You know exactly what it is, and yet it is nothing. It is empty and blank, and the dark colours and the reflective glass make it even harder to see. But this is OK because there's nothing to look at anyway. And of course the glass is like the windscreen of a car or a computer screen.

Opie then animated this view using a computer, and made an endless looped film that was shown on two monitors alongside the paintings at the Hayward Gallery. The film offers a slowly changing view of an empty road. The clarity and simplicity of the graphics perfectly replicate the look of the paintings.

Imagine you are driving provided the soundtrack for the Hayward exhibition; it set the tone. I showed the track sculptures on the floor, the films at the end of the space, and the paintings on the side. You could travel around, and encounter these different things. It was interactive.

Because the view is from the driver's seat, it's not about standing back and looking; it's about being drawn into the movement, which is why it made sense to make a film. I was building up an infinite series of views, and if I animated them I could literally make them infinite. I've always been interested in making drawings that move.

I thought it was interesting to mimic the look of the computer, but I worked it all out by hand first. Only once I had stripped away the detail in the paintings could I then

overleaf: IMAGINE YOU ARE DRIVING
1993 [52]
clockwise from top left: 1, 3, 4, 2
Vinyl stretched on aluminium frame
240 x 336.5 (94 1/2 x 132 5/8)
No.1: Scottish Gallery of Modern Art,
Edinburgh
Nos.2, 3, 4: Private Collection

make the film. I suppose I'd become interested in computer games – I remember playing a Formula 1 racing game, and later, I bought a flight simulation programme and spent a lot of time downloading stills and drawing them. I think the colour choices I began to make were informed by that.

Another aspect of *Imagine you are driving* was a series of model racetracks, cast in concrete. The solid grey mass of these sculptures brought them closer to the reality of the road, whilst they shared the seamless, anonymous surface of the paintings and computer film.

I based the racetrack sculptures on Scalectrix tracks, where you build your own track from various parts. With Imagine you can order these *I used this idea of creating systems, where you had a number of units out of which you could order and build something – inspired by buying kitchen units from Ikea. I got a factory to produce a number of concrete sections – curves, straights, ramps – so that I could vary the construction of each sculpture. I wanted to market them as a system that you could buy into, select your own parts and build your own, although you had to think carefully about how many parts, and how it would fit together. Potentially it could lead to an infinite number of sculptures, all different but the same. I have made three so far.*

Following the Hayward show, Opie used the driving theme frequently and constructed entire installations around it.

I was beginning to build experiences out of an exhibition. Previously it was really about gathering work together and showing it off to best advantage. After this I returned to the driving idea a lot, and it became very useful as a strategy for making exhibitions. Driving turns the world into a story, something to read and look at.

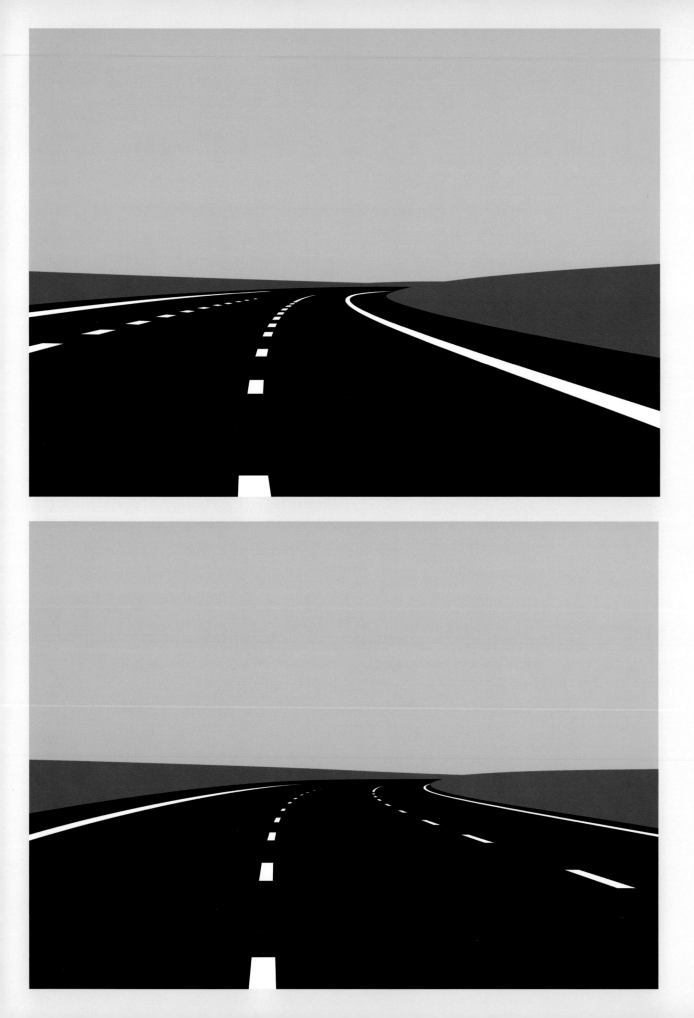

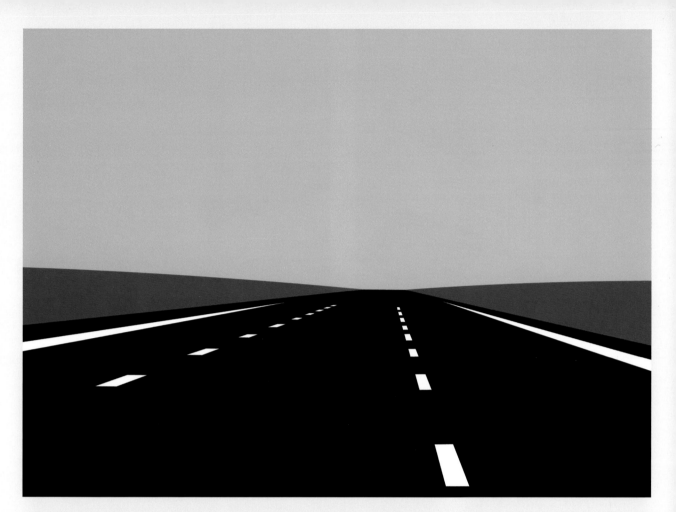

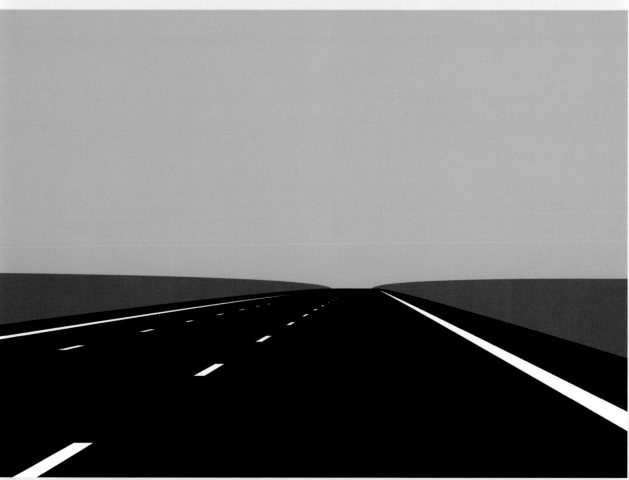

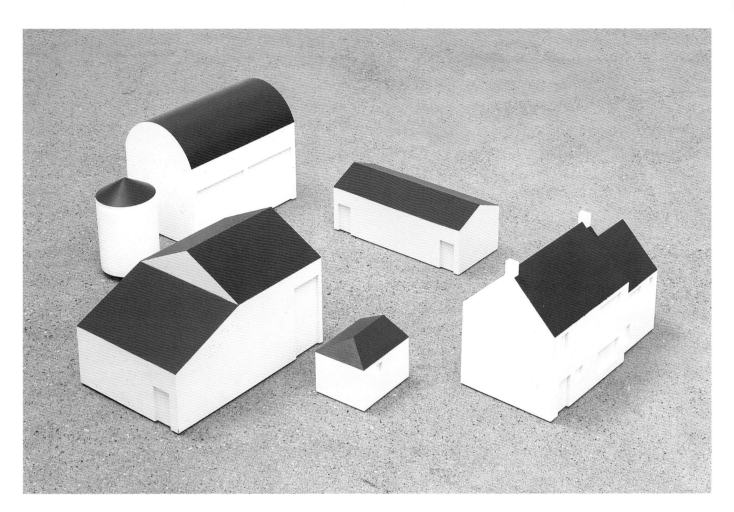

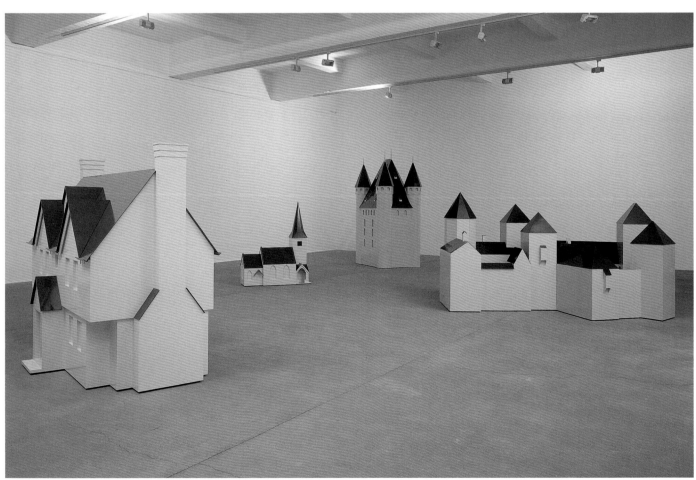

IMAGINE YOU ARE LANDING (FARM)
1994 [53]
Painted plaster
Installation approx. 70 (27 ¹/₂) square
Private Collection, Milan

INSTALLATION, HAYWARD GALLERY,
LONDON 1993 [54]
From left to right: FARMHOUSE 1993,
COUNTRY CHURCH 1993, CASTLE
1993, FORTIFIED FARM 1993
Painted plywood

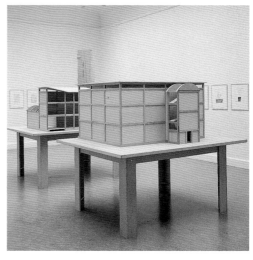

Thomas Schütte
COLLECTOR'S COMPLEX 1990 [55]
Wood
267 x 500 x 178 (105 ¹/₄ x 197 x 70 ¹/₈)
Collection Van Abbemuseum,
Eindhoven, Netherlands

A MODEL WORLD

4

Up until this point Opie's interest in fabricated environments had inevitably led him to focus on urban space, but his field of vision gradually broadened to encompass other aspects of the world. He came to consider landscape as a construction, an impression confirmed by his extensive travels across Europe and America. The theme of travelling dominated his show at the Hayward Gallery – not only through the multiple manifestations of *Imagine you are driving*, but also through the model buildings presented in an adjacent space, which mark Opie's return to more representational sculpture. They were inspired by his experience of driving great distances, and elaborate on the sensation of moving rapidly through the landscape, with all the expected changes of scale and focus. These works relate to many of Opie's earlier preoccupations – with architecture, space and location – but they also evoke feelings of transience, loss and melancholy.

As a catalogue of types, these model buildings make up a vernacular of the architectural everyday. They are classic examples of the kinds of buildings that we can picture in our minds without needing recourse to a physical reality. To strengthen the sense of archetype, Opie titled them simply *country church, farmhouse* and so forth. As generic objects, they are not unlike his earliest representational sculptures, and although they are very different in appearance, their linear, economical style reminds us of Opie's continuing emphasis on drawing.

Opie's models are concerned with a range of overlapping issues, but at the forefront is perhaps the sense of detachment generated by modern life. The uniformity inherent within urban space necessarily shapes our experience of it – towns and cities often seem indistinguishable, suburbs all look the same – and Opie's models appear to mourn the loss

of individuality that comes with a burgeoning corporate landscape.

The model acknowledges but also blocks out human reference, which creates a sense of dislocation. Elsewhere in Europe, Thomas Schütte and Fischli and Weiss were making models that questioned how we, as individuals, relate to the world. Schütte, like Opie, was more interested in metaphor than actual description. His model houses were made from chipboard and lacked detail, but their presentation (on tables) was more theatrical, and they seemed closer to architectural prototypes. The artist Liam Gillick, reviewing Opie's Hayward show, concluded:

Opie's current output has to be viewed in context ... His work increasingly appears to be a reflection on the whole modernist project – not just abstraction and hard-edged objects, but cultural and socio-political aspects expressed through lucid manipulation of forms of near-representation.

Gillick also set Opie apart from other artist/ model-makers since 'the way he translates his experience is both more complete and paradoxically less profound in an accepted recent critical sense. His work is somehow emptier and, therefore ... disturbing.'[15]

That Opie's models came about after a period of extensive travel is pertinent. He had been amassing an encyclopaedic stock of photographs of buildings, ranging from domestic cottages to medieval churches and Rhineland fortresses. The resulting models were inspired by and distilled from an amalgamation of memories and these pictures.

We can make a connection with the table of symbols used in guidebooks and on road signs. The growth of mass tourism has meant that sites of interest are now neatly reduced to symbols on a tourist map. But the artist would not endorse so reductive a reading of these sculptures; he would

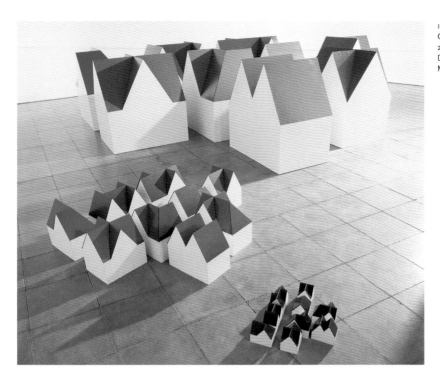

IMAGINE THAT IT'S RAINING 1992 [56]
Gloss paint on plywood
27 units in 3 groups
Dimensions variable
Museet for Samtidskunst, Oslo

rather see them as forming part of a fictional landscape, a backdrop for our own imaginings.

Opie's models trigger various associations, and it is difficult to settle on a single framework through which to view them. Just as we feel remote from them we also feel slightly nostalgic about them. One reason for this might be the clear link with children's toys. Significantly, another source for this body of work was a German model railway kit with its accompanying farmhouses, village churches and cottages. Opie had painted these tiny buildings in sober shades of green, grey or blue, the paint creating a homogenising skin that made them appear generic.

Opie's models also bear a resemblance to the abbreviated backdrops of early computer graphics, and many critics were quick to make the link between this work and computer-generated imagery once again – a language of representation that was outside of everyday reality but tied to it. The experience of making *Imagine you are walking* and *Imagine you are driving* had alerted Opie to the simplified and idealised world of computer imagery. The process of reducing data, like miniaturisation, is associated with forms of artificial intelligence. Thus, the simplification, the scale, the dull, blocked-in colours and smooth surfaces all give the impression that Opie's models could have been pulled out of the virtual world of the computer. They have clarity and restraint, and their exterior surfaces are without texture. Some were also made from concrete – the dull, anonymous surface echoing the muted tones of the painted wood. The power of the illusion might distract the viewer from questioning how each object was made, but it is important to remember that Opie was still fabricating his objects by hand, and spending much time and energy on creating something that looked so effortless and hyper-real.

Imagine that it's raining from 1992, made up of three identikit groups of model houses, best illustrates the metaphors and meanings embodied in these sculptures. The houses are based on the slightly old-fashioned gabled and pitched roof style of Northern European architecture, but are quite abstracted. Each group consists of nine houses, all made from plywood painted in off-white and grey gloss paint, the dull palette adding to a sense of unreality.

Each group is successively reduced in scale by two thirds, and they stand close together on the floor in identical configurations. The smallest ones resemble toys; the medium-sized ones could be some kind of architectural model, whilst the largest ones are too big to be either. Viewed together, these groups seem to combine an aerial perspective with a planar one due to the shifts in scale that occur between them. The fact that they are shown in ever-shrinking format suggests that they are the result of someone experimenting with a computer programme, and there is something jarring about being presented with such an old-fashioned architectural style through what looks like a computer simulation.

In *Imagine that it's raining*, the lack of any particularising feature, combined with this ever-shrinking scale, means that no matter how close we come to these models we still feel as if we are seeing them from a distance. Moreover, even when we do look at them close up we are disappointed because they have no interiors and thus it is impossible to gain any more information about them. It is a sanitised image – domesticity at one remove. However, these models are not inert boxes and can reactivate all kinds of memories. The viewer might feel a certain sense of longing or nostalgia, remembering dolls' houses. The models might also incite a sense of reverie reminiscent of that present in child's play. Opie makes

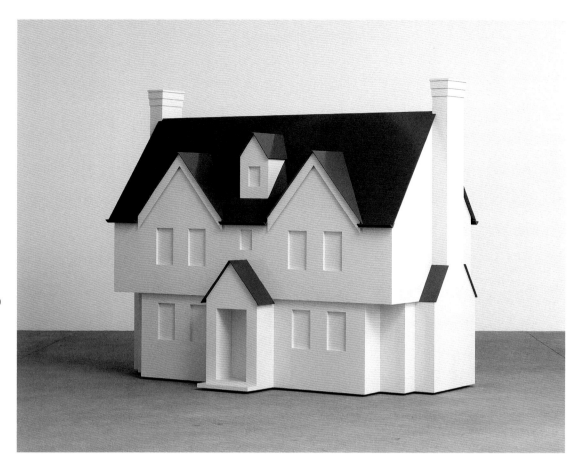

FARMHOUSE 1993 [57]
Painted plywood
175 x 120 x 230 (68 7/8 x 47 1/4 x 90 1/8)
Massimo Sandretto, Turin

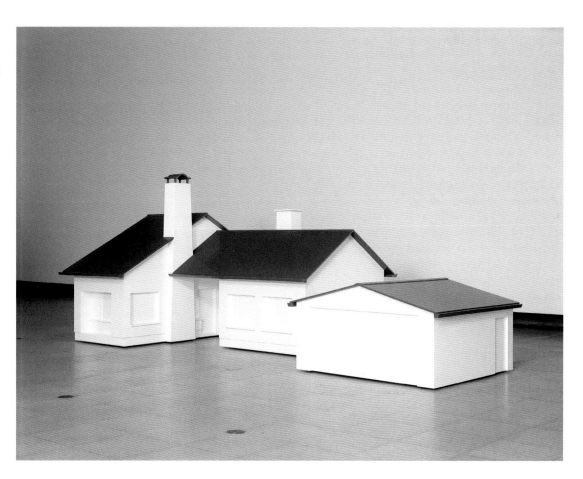

BUNGALOW 1993 [58]
Installation, Haywood Gallery,
London 1994
Painted plywood
120 x 210 x 180 (47 1/4 x 82 5/8 x 70 7/8)
Centro Cultural Arte
Contemporaneo, Mexico

Fischli and Weiss
STILL LIFE/OBJECT/REAL LIFE
2000 [59]
Installation, Tate Modern,
London

more of this through his titles, animating the objects with a suggested narrative. *Imagine that it's raining*, for example, clearly makes reference to the function of the pitched roofs, while *Imagine you are landing*, which he used a number of times for the smaller models, invokes the idea of flying in an aeroplane and looking down over a landscape.

If the body is the norm by which scale is perceived, then the size of Opie's model worlds continually confuses. All are placed on the gallery floor and occupy the same space as the viewer. But in purely perceptual terms, their smallness denies us the sense of a completely shared experience. The fact that they might only come up to knee level has the effect of pulling our vision downward, forcing us to crouch in order to get a better look. So it is mildly discomforting to encounter them, and no matter how close we come, we are still excluded.

In the wake of the Hayward show, Opie shrank the scale of the models further, building on the metaphor of flying. He recalls seeing an exhibition by the American artist Joel Shapiro at the Whitechapel Art Gallery, which proved influential. Describing 'these little sculptures – a running man, bridge or house – laid out across the floor of the upstairs space', he adds, 'my interest was not in the sculpture itself but its effect on the surroundings, how it transformed the space.' Shapiro's small sculptures insist on an intimate experience in a public situation. A tiny object in a huge gallery shifts the private into the public sphere, and highlights the difficulties, the anxieties and the ambiguities of relating the individual to the public and communal. Opie's objects carry the same kind of tension.

In the exhibition *Paysages*, in 1995, held at the Galerie de l'Ancienne Poste in Calais. Opie presented a series of tiny models:

We made wooden moulds and poured plaster into them. I think we made about fifty different buildings in the end. They were spread about across the floor, and later I grouped them together in configurations to suggest a village or a farm, and that again was taken from the experience of flying and looking down at the world. It was also, of course, very similar to the ethos of Imagine you can order these, *where you could re-order component parts within a whole.*

The relationship between two-dimensional and three-dimensional works remained unclear, however. Opie had begun making landscape paintings based on images downloaded from a flight simulation programme. These are the first instance in which he directly used the computer for source imagery, but he had yet to resolve the scale of these finished paintings.

When he participated in a group show in Pescara that same year, Opie combined and enlarged both sculptures and paintings:

*I realised I had to build the models up to a scale that confronted you physically, and the paintings had to match this, to become more like theatrical backdrops. I made a digitised version of a Constable landscape. I drew over it, simplified it to make a more stylised view (*English Landscape (1) *1995) and I put a model of an Italian factory building in front of it (*You see a factory *1995). In a sense I wasn't doing anything out of the ordinary: putting a painting on a wall, and sculpture on the floor. But together they made a three-dimensional painting.*

From this, Opie developed his ideas and extended his repertoire beyond buildings. He began to include other objects from the everyday world, creating his own compressed version of reality and elaborating on the idea of making a picture to walk into. As ever, he placed more emphasis on the generic than the specific. A car is reduced to an angular, standardised form (flat shiny surfaces, painted-in windows); trees

overleaf: DRIVING IN THE COUNTRY
1996 [60]
Installation, CCC Tours, France

are plywood cut-outs that look like stage props; and tower blocks are rectangular boxes with black and white grids for windows. The aesthetic is one of elegant playfulness, simplified but succinct. Despite their flat, pictographic quality, all the objects have a physical presence and relate to human scale. They create an actual place to be explored, and although we know they are not real, they are physically persuasive. When set against the two-dimensional backdrop of an idealised, simplified landscape of rolling hills and blue skies, the illusion is complete.

Opie's abbreviations of contemporary life again echo the economy of computer graphics, where a brown line topped with a green circle represents a tree, and three such 'trees' represent a 'forest'. The world he was creating was close to what we might find in a computer game, where a very basic context is generated so that the action may then develop. Significantly, Opie left people out of his repertoire, and it is up to us to take on the role of protagonist and player, activating the drama and narrative flow. We can give life to these objects using recollected experience, accepting they are not real but still playing the game. The emphasis on archetypes and generic forms inspires the creative imagination. Individual objects can carry a whole range of meanings and can come together to make a narrative, as the titles demonstrate: 'You are in a car. You see an office building. There are hills in the distance. You pass a castle.' Simple phrases turn into sentences.

On first encountering these works, many people also related the imagery to children's books or toys. The child-like innocence, the kindergarten colours and the cartoon-like quality are reassuringly familiar, accessible, appealing. By referring to the iconography of modern childhood, Opie is reminding us of a simple, safe time, but he is also making the connection with how, as children, we begin to construct strategies for interpreting and understanding the world:

My child was starting to explore the world and that put me back in touch with my own experiences. Partly by paring things down, I was making a child-like version of reality. I'm not saying that's how children see the world; I'm saying that's how the world is presented to children ... It's how they're taught. They learn to use and recognise things in the world through scaled-down equivalents. In these forms things become knowable. When you teach, you need to turn reality into a common language.

Like the building blocks of *Imagine you can order these,* Opie's objects are to be seen as component parts of an overall scheme that can be built up, sorted and arranged in different ways to create different narratives, and varied according to the needs of new environments. Opie had evolved a methodology of making work that was also a practical solution to exhibition making. This same body of work was shown in a number of different forms in 1996 (but perhaps most prominently in *Driving in the Country* at CCC Tours in France and in *Imagine you are Driving* at the Lisson Gallery). It varied in each presentation according to the space, as was Opie's intention. By taking responsibility for fabricating whole environments, Opie mirrored the way in which civic spaces are planned out and constructed, where functional units are combined to make a cohesive whole. The fact that he instructs, telling us what we see and where we move, reinforces the idea of an over-arching formula that has little regard for individuality. This is perhaps a fair reflection of our present reality. Thus, despite their shiny surfaces and bright colours, Opie's invented spaces seem tinged with a certain sense of ennui and melancholy.

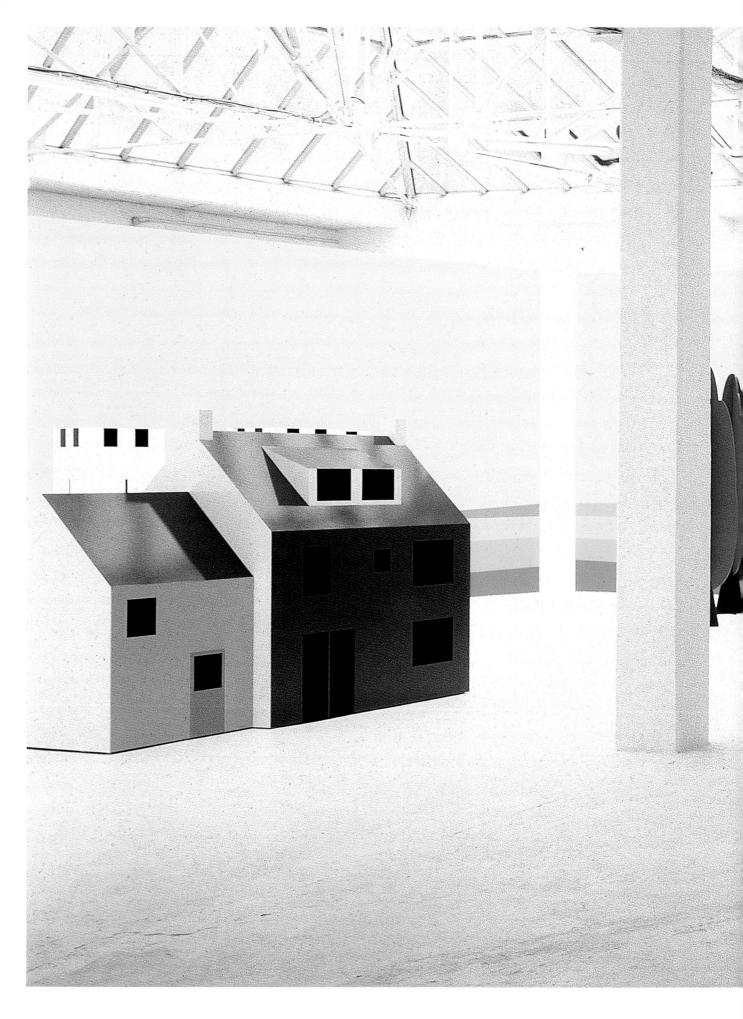

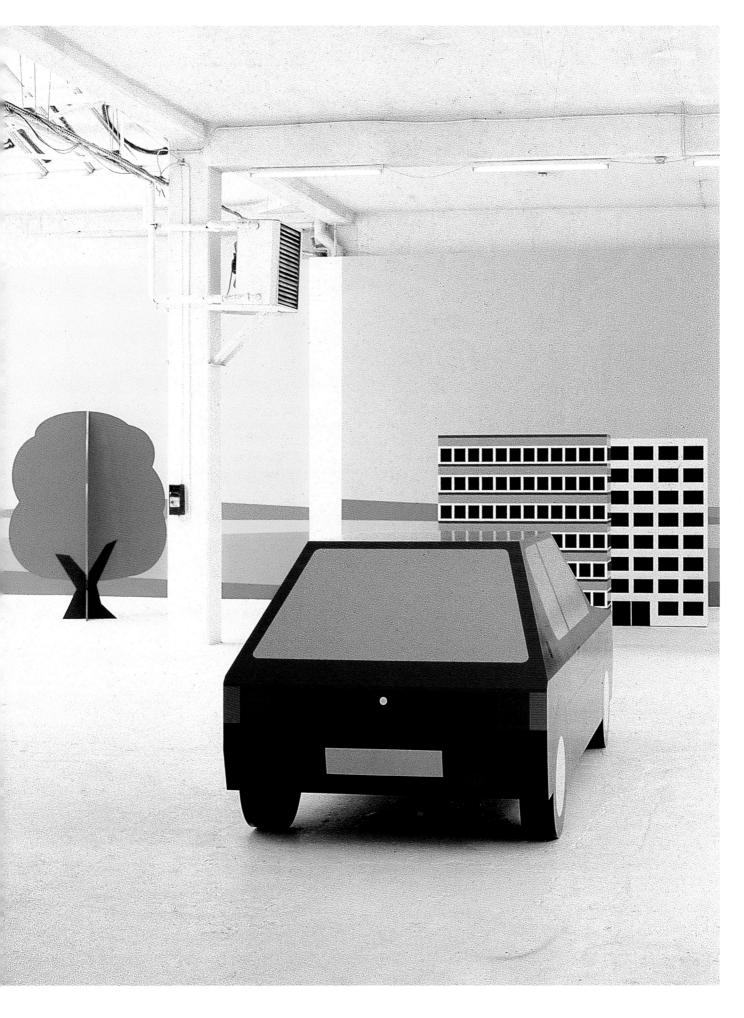

MARY HORLOCK *Driving in the Country* offered a simplified view of contemporary reality, an environment where things like cars, buildings and even landscape views are reduced to a sophisticated sign language. Beyond the specifics of this exhibition, they were part of a bigger scheme that allowed for lots of versions and variations. Your plan was very ambitious, both conceptually and practically. How did you conceive of it?

JULIAN OPIE For me, making exhibitions is about learning, bringing things together. What I was trying to do was to combine two of the rooms that I'd made in my exhibition at the Hayward Gallery, breaking down the wall between the model buildings and the large wall paintings, and creating a unifying language to contain the two.

What I was aiming for was a repertoire of possibilities. I was suggesting that I could become a factory and create an inventory of things, objects, rather like Ikea. Curators could come to me and I'd be their guide; with my help they could select what they needed to create a show. I set about consciously making a catalogue of objects that could be used in different spaces, in different combinations. I had two or three sets of trees, three or four suburban houses, five cars, six office buildings, all built in three dimensions, in plywood.

During my residency at the Atelier Calder in France in 1996 I had time, money and one or two assistants, so I could do this. CCC Tours was in the neighbouring town. Because of the nature of that space, *Driving in the Country* was the best presentation of that body of work, but I also showed it in two galleries in Switzerland, and in London, and in Milan. None of the objects was easy to make, or store or transport. It was quite stressful, and the other question that haunted me was what any of these objects meant individually. If you adopt this system you need more than one object, obviously. Generally I did sell them in groups: that was my idea – a very optimistic one. The Tate bought four tower blocks and a car and a wall painting, which was ideal.

MH Each object functions more like a sign or symbol, but it occupies the viewer's physical space. The scale fluctuates – the car is almost life-size, whilst the houses were smaller, as if seen from a distance – was this the idea?

JO All the objects relate to human proportions. The houses were based on the houses you find in Italian graveyards, modelled on another scale for the dead. The car was probably 95 per cent full size. The tower blocks had to be big enough so that you couldn't see over them. The trees had to be taller than you in order to be trees (but not much taller).

MH Were particular objects more important, more successful, than others? The cars were obviously central, since they activate the narrative.

JO I worried a lot about the cars. They're difficult things to use in art because they're such designed objects. I found that I had to go for quite ugly, boxy types – the kind that say 'This is what is out there'. I was pleased when someone pointed out to me that each side of the car was like a painting, a fairly abstracted, geometric painting. The office buildings were more resolved though; they took up less space than the cars but still had a strong

physical presence. They also presented this flat picture plane, and on it an abstract painting.

MH The surfaces are obviously crucial – their perfect, pristine finish. It makes the objects appear hyper-real, as if they'd been pulled straight out of a computer screen.

JO I had to make them seem different; they had to be 'transformed objects'. The look of perfection was important; under the paint you had these quite clunky wooden constructions. I experimented with finishes. When I painted the cars gloss, they immediately became flatter and smaller, so they still had this physical power but were mysterious and sort of intangible. The office buildings use a mixture of matt and gloss: the body of the building was matt, but the image floated onto it was gloss. The wall paintings were matt, as I wanted to flatten them and also to make the walls disappear. It was a delicate kind of equation, working out the surfaces, and then the lighting and the placing of the objects in the space, as well as determining things like the angle from which you entered the installation. Little differences were vital, although they don't sound that interesting.

MH You've talked about this idea of making a picture for the viewer to walk into, but you never completely transformed the space – you've never changed the floor, for example. The white floor at CCC Tours constantly reminds us that we're in a gallery, and that these are art objects.

JO The floor always presented a challenge for me. I had to ask: was it part of the work or part of the gallery? At CCC it was very white. At the Lisson you have these grey tiles. There was always a tension, but I didn't want to make a stage set. I wanted to follow the logic of a gallery exhibition: paintings on the wall, sculptures on the floor. I wanted to give you pretty much what you expected. This was as close to realistic as I could get.

MH Perhaps you should define precisely what you mean by 'realistic'.

JO What I'm asking people to do – and this is something I do often – is like this: when you're on a train, instead of looking out of either one or the other window, look out of both at the same time. You can do that, if you look down the carriage, relax a bit, and don't focus. You see movement, and a kind of panorama. It doesn't have meaningful detail in it. What's meaningful is you and the movement, and your sense of space and sky, colour, the quality of the landscape. You get more of a frisson of reality if you, the viewer, activate the picture. That was what I was trying to capture. I was trying to compress that realism, that quality of presence.

YOU WALK THROUGH A WOOD
1995 [61]
Installation, CCC Tours, France 1996
Oil-based paint on wood
3 parts: oak tree 215 x 165 x 165
(84 5/8 x 65 x 65); cypress trees
265 x 80 x 80 (104 3/8 x 31 1/2 x 31 1/2)
background: THERE ARE HILLS IN THE
DISTANCE (2) 1996 (detail)
Paint on wall

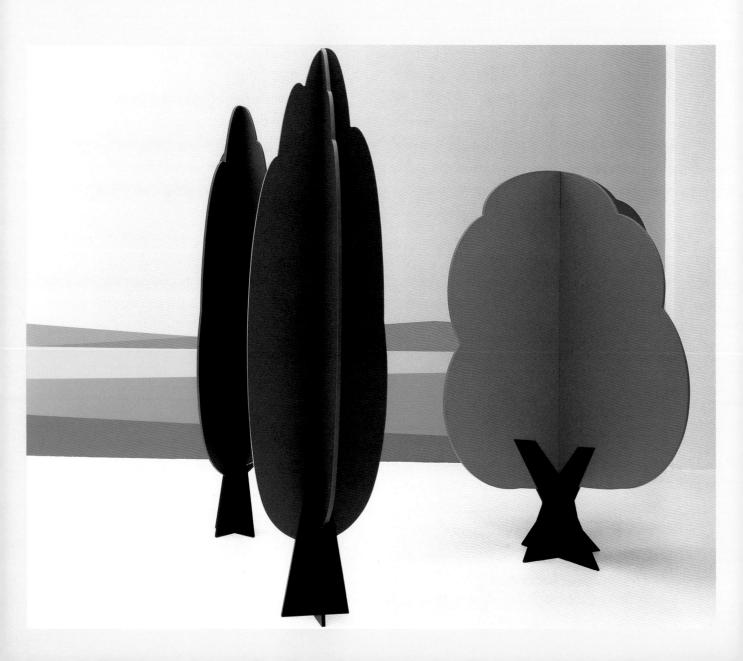

YOU ARE IN A CAR (PEUGEOT 205) 1996
[62]
Installation, Lisson Gallery, London 1996
Oil-based paint on wood
125 x 138 x 336 (49 1/4 x 54 3/8 x 132 3/8)
Private Collection
background: YOU ARE DRIVING ALONG
1996 (detail)
Water-based paint on wall
Private Collection

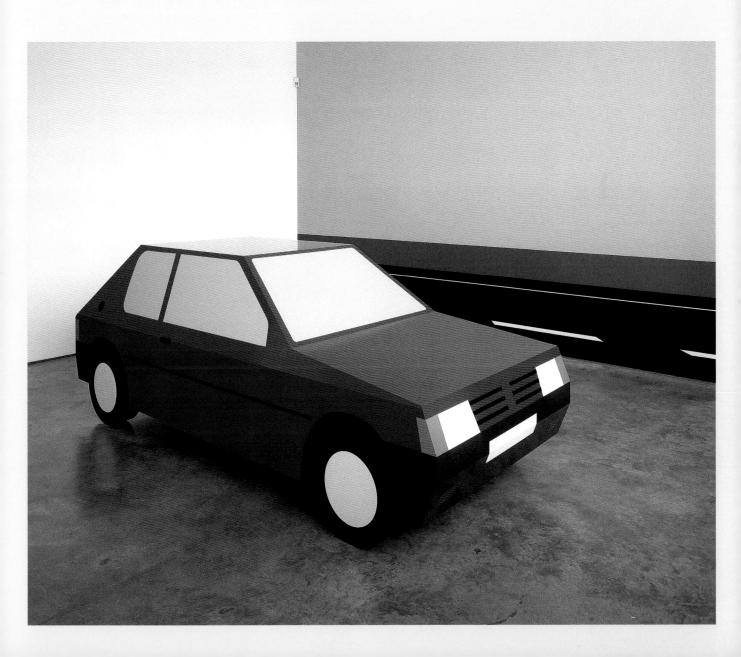

YOU SEE AN OFFICE BUILDING
(2, 3, 4, 5) 1996 [63]
Installation, Lisson Gallery, London 1996
Oil-based paint on wood
184 x 157 x 45 (72 $\frac{1}{2}$ x 61 $\frac{3}{4}$ x 17 $\frac{3}{4}$) each
Tate
background: THERE ARE HILLS IN THE
DISTANCE 1996
Water-based paint on wall
Tate

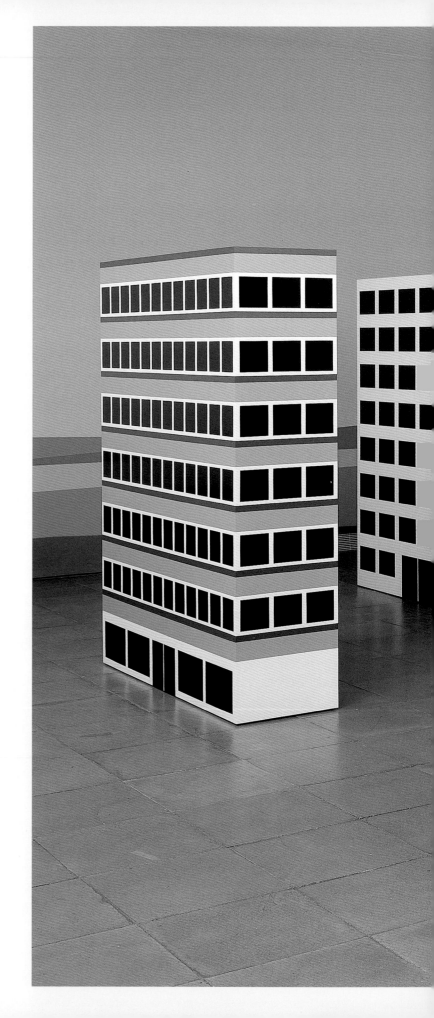

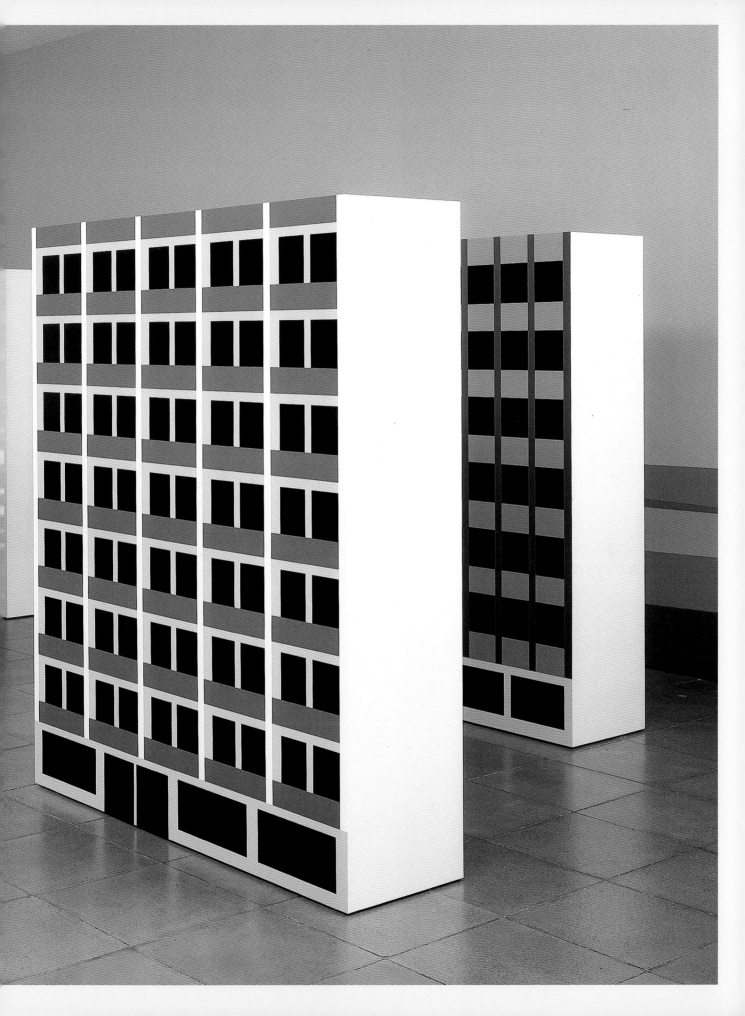

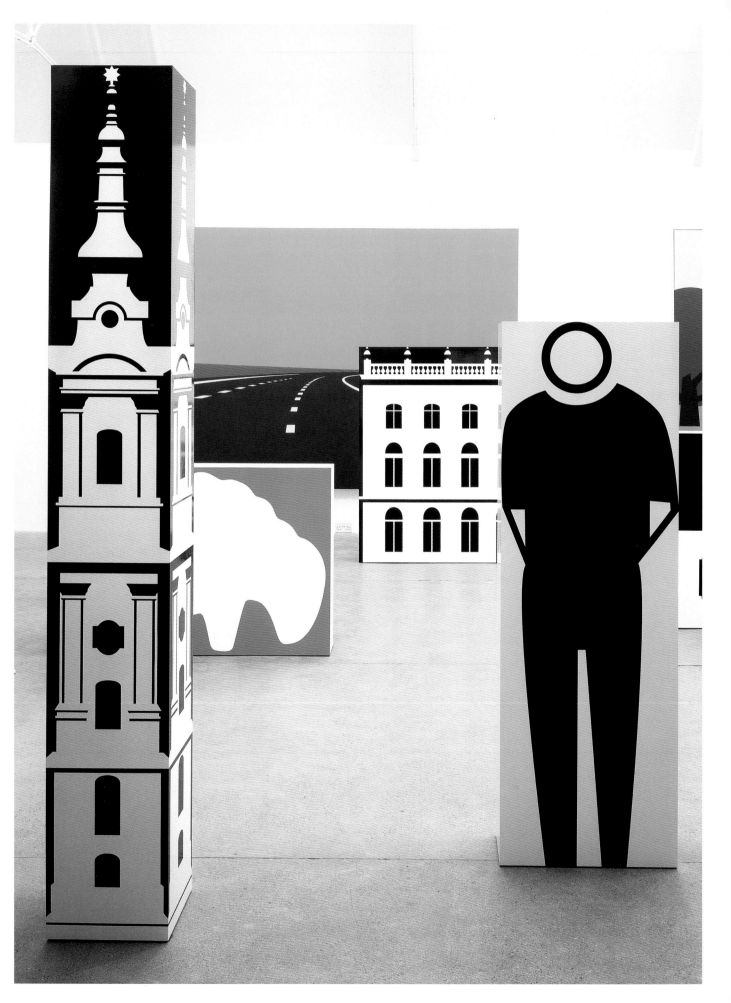

5

SIGN LANGUAGE

Shorthand images are everywhere in the contemporary world. Signs and logos tell us what we need to know quickly and effectively, and we have come to rely on them without even realising it. Opie's pared down repertoire of forms engaged with this symbolic language. Familiar and reassuring, his objects conveyed information without seeming to demand close scrutiny. The surface area is a determining element in our world of transitory visual impressions, and Opie exploited it to the full. Although three-dimensional, his objects appeared to be all surface.

Having built up an extensive visual vocabulary, Opie set out to refine it in preparation for his participation in the 9th Indian Triennale in 1997. His desire was to compress the physical aspect of his objects in order to make them more mobile and therefore more versatile. The office buildings suggested a way forward, being rectangular and narrow, not unlike a canvas. He realised: 'I could paint anything on the boxes, and then you could "read" them. This would be enough for the human eye and mind.' Developing an abbreviated version of the earlier series, 'I ended up putting all the painted objects – cars, buildings – onto flat boxes. I'd realised it wasn't necessary to build a full-scale world. Just a few suggestions were enough.'

What we now see is Opie condensing his imagery. The pictures painted onto the wooden boxes were little more than a simple outline with minimal colour (the churches and tower blocks being monochromatic). These images did not fit perfectly onto each block; the block functioned like a screen and the image floated away from it, like an illustration from a child's pop-up book. This allowed for new additions to Opie's vocabulary – more organic forms that might have proved difficult to fabricate previously – notably people and animals. In a sense,

they completed his world. Significantly, Opie felt these abbreviated forms were able to function independently of each other as well as in groups:

I see the sculptures as functioning a bit like objects in an Ikea catalogue. They can exist on their own but are also capable of being combined in many different ways with other objects from the catalogue, to create a larger whole; an exhibition in my case or a home in the case of Ikea.[16]

These works were first shown in Delhi. As component parts of a whole they could be selected, arranged and re-ordered in new ways, and they were reconfigured for each venue of the exhibition tour according to the possibilities of the space.

As 'imaginative compressions' these images were far from realistic, but they created an idea of reality, a virtual reality. The computer now had a very immediate relevance to Opie's concepts and their definition. The pin-sharp clarity, the flat unmodulated colour and the pristine finish all meant that the viewer looked directly at the image without being distracted by any activity on the surface. This made for a singular, fast type of 'reading' of each image, as with a computer interface.

The legibility and accessibility of Opie's language was a powerful reminder of the speed of contemporary life. The work encapsulates the modern condition of accelerated experience. It could be said that technology is moving too fast for us and that in our daily lives we tend to see 'in general', taking in the salient points about an image, extrapolating details without remembering things precisely. Opie captures this, depicting how reality feels as well as how it looks. There is an unresolved paradox here: how do we deal with our conflicting enchantment and disillusionment with the modern world, a world of machine- and mass-manufacture, information superhighways and cyberspace? Opie

INSTALLATION, 'ARTISTS FOR
SARAJEVO', FONDAZIONE QUERINI
STAMPALIA, VENICE BIENNALE 1997
[65]

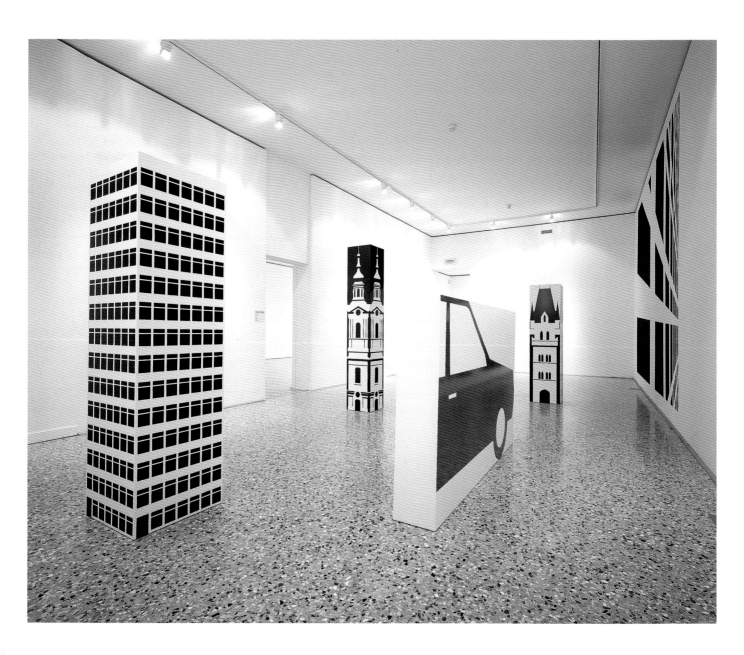

SITTING ARMS AROUND KNEES 2000
(22 x 23 x 5.5), KNEELING HANDS IN
FRONT 2000 (32 x 18 x 5.5), LYING UP
ON ELBOWS 2000 (15 x 35 x 5.5) [66]
Installation, Alan Cristea Gallery
Vinyl, wood, paint

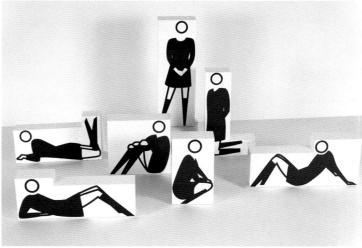

7 POSITIONS, BOOTS, BLACK DRESS
2000 [67]
Vinyl, wood, paint
Standing figure 31 x 10.9 x 5
(12 ¹/₄ x 4 ¹/₄ x 2)
Collection the artist

infiltrates this world and adopts its language, but shows no desire to subvert or undermine it. Critics found his neutrality frustrating, but it was perhaps the most accurate reflection of our own neutrality towards things that are ubiquitous in the modern world – the high-rise office block, the crowds and traffic.

Those who dismissed Opie's language as facile were missing the point. The simplicity of his imagery disguised its depth. If anything, Opie was emphasising the complexities of the visual world. By stripping everything back to basic forms he liberated objects from their specific burdens and meanings. The detachment and ambiguity so much in evidence were vital. By preventing subjectivity from manifesting itself in the finished work, Opie pushed the viewer to respond directly. As with all art, we have to engage intellectually and imaginatively with the work, register meanings through subjective experience. The emphasis is on the active nature of looking. Opie wanted to shake us out of the automatic responses that characterise our interaction in the everyday world. He was also making us newly aware of the richness of references that a simple sign or symbol can carry.

People

The computer began to assume a central role in Opie's practice: it allowed him to develop his systems in abstract space before realising them in actuality. His key concepts were unchanged: the balancing of the generic and the specific, pitting realism against representation, and the working through of serial forms. Computer technology enabled Opie to develop new subjects whilst simultaneously expanding and refining his symbolic vocabulary to a degree of perfection. Concordantly, his installations became

more multifarious in nature, translating his experience of people, cities and landscapes into a universal language of signs, brightly coloured and immaculately presented. Opie would select from and combine different bodies of work.

Opie sought a way of bringing people into his existing inventory of signs, and this activity soon developed a momentum of its own. He approached the human form by first selecting the most standardised representations he could find – looking at signs and symbols in the real world, such as those used to indicate male and female lavatories. He then combined this with a digital photograph of a real person. He merged the two using a computer-drawing programme. 'I input the photograph on the computer and drew over it with the sign, bending the lines enough so it was still a sign, but also relating to the individual, combining the impersonal and the personal.' Opie would refine the image by eye: getting back to a basic form but keeping particularities that might reveal something about his model. The first figures were elegant and laconic: little more than a blank circle floating above a body that was essentially defined by an outline of clothes. Initially Opie's motive had been to make anonymous 'passers-by' with which to populate his world – a woman with a handbag over one shoulder, a man with his hands behind his back. They looked like signs but were subtly enhanced, more suggestive, and fitted seamlessly into his invented world.

With each figure certain features – the choice of clothes or the posture: a hand resting on a tilted hip, head up and arms crossed – were consciously used to enrich the depictions. Thus, he never completely erased the personalities of his models, and their particularities became more prominent through the reduction of everything else. We expect a

Wall (from left to right): MONIQUE
TOP SKIRT 2000, TESSA JACKET
TROUSERS ARMBAND 2000, MIGUEL
T-SHIRT SHORTS 2000, ELLY HANDS
ON HIPS LEGS CROSSED 2000 [68]
Wallpaper
Lisson Gallery, London

WOMAN TAKING OFF MAN'S SHIRT IN
THREE STAGES 2003 [69]
Vinyl and paint
right: ELENA, SCHOOLGIRL (WITH
LOTUS BLOSSOM) 2002
Wallpaper
Installation, Neues Museum,
Nurnberg

fundamental utilitarian correctness from signs, but details like this are undermining. The figures are more ambiguous and more alluring as a result.

Characteristically, Opie tested out every option: different models in different poses; different models in different poses and different clothes (*People* 1997); the same model in different poses (*7 positions* 2000); the same model in different clothes. He then denoted the differentiations through the titles and would frequently refer to his subject by name (*Gary t-shirt jeans* 2000, *Brigid trousers top hands on hips* 2000), thus maintaining a sense of individuality within the multiplicity. But it is hard to know how to read these figures when viewed either collectively or individually. Their serial forms prompt us to think about society and how we relate to one another and resemble one another, and inevitably we have to ask whether we are all reducible to predefined 'types'.

The desire to rationalise the human form has preoccupied artists for generations, but Opie gave this a new twist with the stylised symmetry of his figures. It is the incongruity between the soft and human, and the hard and artificial, that makes them so troubling. This was most acute with the nudes. Echoing imagery that derives from advertising brands or logos, Opie's nudes were drastically reduced: a simple outline of torso and limbs, a circle for the head, two curved lines for breasts. Whereas before, the clothes acted as a defining feature for each model, now there are simply suggestive contours. The position that each figure assumes becomes focal: poses that are familiar and recognisable, to which we can relate from our own experience (such as *Lying on back on elbows, knees up* 2000 or *Sitting hands around knees* 2000). It is intriguing to see something so particular and human captured in such a structured, graphic language.

Portraits

After studying the figure in full length, Opie came to focus in on the heads of his models, testing out the same technique: drawing over individual photographs on the computer, reducing and abstracting the image:

The first drawings were very simple, but that gave me a language on which to build. They started as black and white, with very pared-down parameters – the mouth was just a straight line and so on – and bit by bit I adjusted it until it seemed like the right balance between someone real and this generic form.

The portraits are graphic outlines: buttons as eyes, two dots for nostrils, a mouth suggested by a long, upper line and a short, lower line, and eyebrows that are two clean 'brushstrokes' leading away from the middle of the forehead. There is an identifiable schema, and these features become part of a series of identikit variations, returning to the concept of modularisation. Like the full-length figures, they are a sign language. As the critic Tom Lubbock wrote:

They're portraits in the style of road signs, as if people who devised hair-pin bend warnings had been asked to turn their language of fat, black lines to the fine particularities of individual likeness – and had succeeded beautifully.[17]

The lack of particularity reinforces the idea of 'types'. This intrigued Opie:

I think the whole notion we carry of people as examples of types is very interesting ... There are some key famous people who become these types and I want to extend that really so that everybody is a type if you draw them in the way that I do.[18]

He later added, 'I want it to be as if each person I draw were a multinational company with a logo.'[19] Each portrait carries the name and profession of the model (*Gary, popstar* 1999; *Max, businessman*

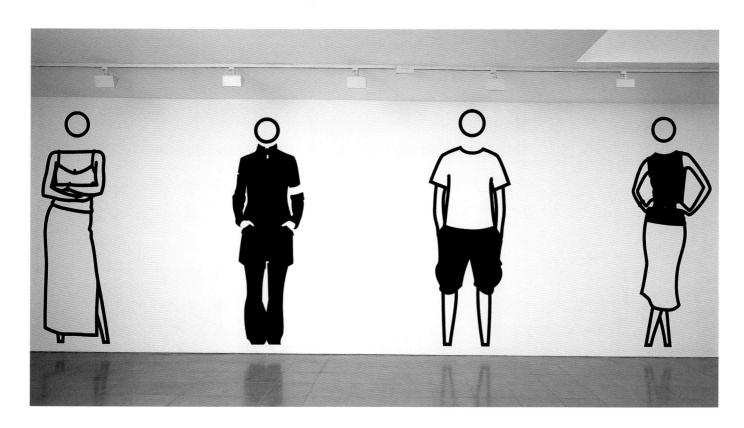

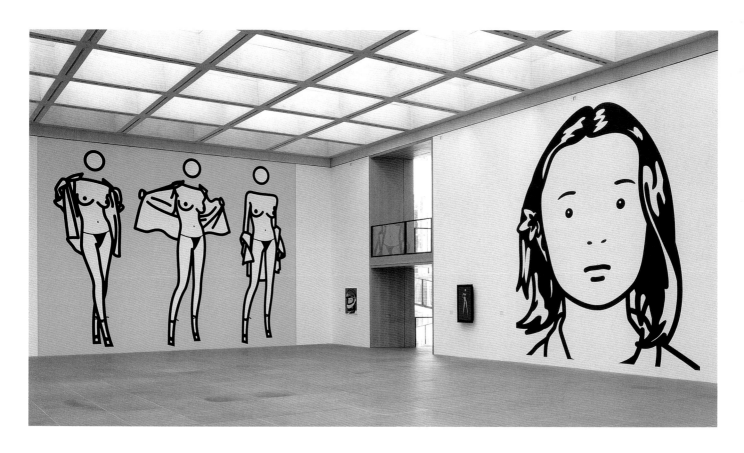

WALL AT WORCESTER ART MUSEUM,
USA [70]
Wallpaper
from left: KATE, MODEL 2001; MAHO,
GALLERY DIRECTOR 2001; MARK,
WRITER 2001; STEPHANIE,
INSURANCE BROKER 2001

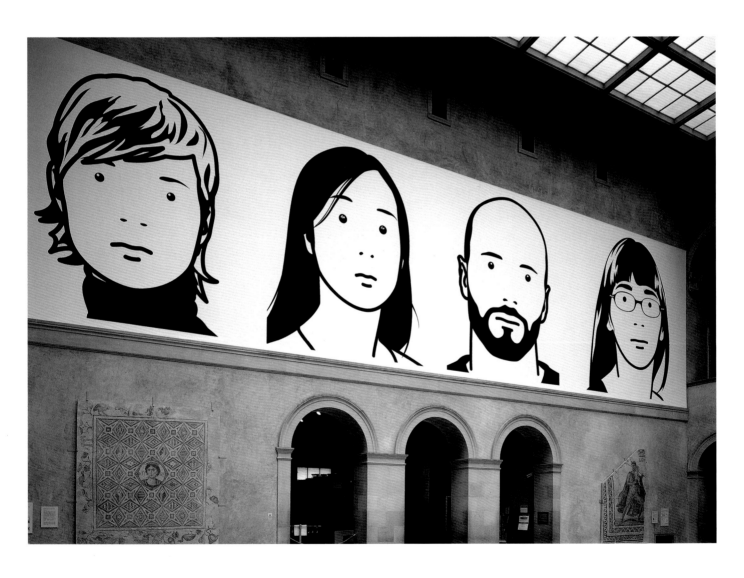

2000). Possibly as a result, their features take on a new resonance.

I liked adding their job titles. Sometimes it seemed to fit and sometimes it didn't; I saw it as another way of classifying and identifying people. I also think it avoids the feeling that I know them but you don't.

But despite the graphic reduction, individual likenesses are never lost, and *Gary, popstar* is a good example. Opie drew him a number of times, with hair short or long, with or without sunglasses and beads, but each time we know him instantly. What becomes apparent is that each person, no matter how schematised, is still distinct: the tilt of their head, the fall of their hair or the arch of their eyebrows defines them; and their clothing and accessories are all treated individually. The differences between each person appear much more pronounced when we see a number together, and (as with the full-length figures) Opie has usually shown them in groups.

Like his figures, Opie's portraits are executed in different sizes and formats. He would always photograph and draw his models in various positions, and out of these serial drawings he has also developed simple animations, using movements such as nodding (*Daniel Yes* 1999) or shaking the head (*Christine No* 1999), blinking or, later, walking. The incongruity of something so fugitive, fragile and human vies with the production of these works, which is stylised, mechanical and impersonal. Moreover, the actual experience of watching such simple gestures in perpetuity is unexpectedly captivating.

Opie's people and portraits are all processed through objective observation and technology, and then perfected by the artist's own hand and eye. But Opie's style is a 'non' style, as if a special computer programme could abstract and reduce reality to quintessentials and fabricate them in multiple forms. This is part of the effect. The reality is that Opie's labours are disguised in much the same way as his models are: subjectivity contained within an impersonal, hard-edged syntax. This ambiguity is very effective. When we look at representations of the human form we think of ourselves, but Opie's people are blank reflections: the eyes in his portraits are empty pools; the standing figures are faceless.

Landscape

Opie's general landscape views were scene-setters in the earlier installations, the backdrop against which the narrative unfolded. Now made in varying sizes, they can still offer a context for his standing figures. The computer has enabled Opie to distil imagery from an ongoing archive of his own photographs along with other sources as diverse as video games, illustrations on milk cartons, and paintings by John Constable. Opie strips everything back to basic form, giving primacy to the generic. The picture-book graphics and primary colours trigger different responses that vary with the scale – whether the work is realised as a grand modern master or made into a small souvenir.

More recently the slick, impersonal style of the computer-generated image has become the foil for more personal subjects. Some views are accompanied by a written list of sounds, and the results are evocative: 'crickets, voices, music' accompanies a stylised nocturne of distant urban lights and a near full moon; 'waves, seagulls, voices' frames a view of water dappled with sunlight. It is hard not to imagine listening, conjuring the sounds we know intuitively from memory. Opie has also used scrolling LED to relay a text and has employed actual sound. For example, *Waves, seagulls, voices* exists as a painting or

Utagawa Hiroshige
VIEW OF MOUNT FUJI 1830s [73]
Wood block print
Collection of Julian Opie

wallpaper with accompanying beach noises. In each of these works, nature is framed by artifice; the two overlap and we treat the artificial as if it were real.

The artist always manages to conjure a mood of reverie that softens the experience. Opie might be suggesting that although everything can be reduced to a graphic outline or a generic view, experience is always personal and specific. Looking is an activity that involves the mental processing of pre-conceptions, associations and ideas, and this is highly subjective. It is also dependent on memory, and what we recollect is rarely accurate, rarely precise, yet from it we still create meaning. Opie offers an incomplete narrative in each of his landscape views – and we are invited to complete it.

Ongoing Multiple Possibilities

All of this work is now developed on computer before being defined in actuality. It is only at the final stage of production that a drawing becomes a work, executed as paintings in multifarious sizes, sculptures on metal, wood, or as concrete casts, as wallpaper, animation, signs or billboards. Opie's work is a series of 'options' stored on computer files that can be called up if and when required, and tailored to relate to any space. The computer allows him to explore all the possibilities that each image holds. A portrait head could be realised as a giant black and white wallpaper motif, or as a colour portrait in four sizes, or even an animation, and a nude might work in three sizes as a painting and in vinyl on wooden blocks or as vinyl applied directly to the wall or glass.

The computer occupies a useful place that did not exist before, somewhere between a final work and a thought. Before, I used to think, draw, and then make something. But now I can think and draw on computer, continue to work it through, and I can leave it there – it's not like a thought

that dissipates – it can just stay in the computer and be outputted when I've decided what to do with it. A drawing is inflexible by comparison; you can't change its scale or its colour without destroying what you've already done.

When he fixes on an idea, Opie will work through all its possible permutations. The computer has greatly enhanced this activity, but inevitably it has become more difficult to visualise the full range of options available. Indeed, by 2001 Opie knew his repertoire had expanded beyond what any single exhibition could present. When he was preparing for his solo show at the Lisson Gallery that year, he realised that the only way to make a comprehensive presentation of his work was through a publication. He took the bold step of adopting the style of a flimsy mail-order catalogue, offering a consumer's guide to his work with every genre and type laid out and listed in a colourful assortment of typefaces typical of such brochures. The actual exhibition offered 'samples' from this on-going production – nudes, portraits and landscapes – with the catalogues stacked up in piles by the reception desk, free for everyone to take.

The catalogue that accompanied Opie's Lisson Gallery show in 2001 brought together a selection of over three years of work in the format of a mail-order catalogue. Its pages are packed with information about the work, and bold typography announces the various categories on offer: animals, people, portraits, buildings, roadscapes; and in a range of formats: sculptures, prints, computer films, wallpaper. Following the logic of a sales brochure, different categories are presented in the most direct way: images of each work sit alongside shots of them in situ, together with details of different sizes and options available within a single type. Straplines such as 'dimensions variable, paint or wallpaper' and 'One day installation/Easily removable' mimic the look of a cheap trade brochure. The fact that Opie provided full details of all prices and editions sparked a considerable amount of debate. Does it denote a new freedom, the democratisation of forms, or does it signal the collapse of everything into commodity culture?

Michael Craig-Martin commented:
Looking at the world, looking at the Argos catalogue, and then putting your art through that kind of lens and seeing what happens – this is so much riskier than what most people consider a risk – this is a <u>real</u> risk, and done entirely with the conviction that this is a proper thing for an artist to do, and having set out on this path, to not follow it through to its own logical conclusion would be dishonest.[20]

Publishing such a catalogue also raised certain issues for Opie's gallery, although Nicholas Logsdail, the Director of the Lisson, felt it was:
a calculated risk. I hoped our audience was sufficiently intelligent to appreciate the irony of it, rather than be shocked by the apparent commercialism. It was far more exciting to do something that seemed so contrary, that broke every rule of the art business. I think Julian is intentionally naive. He frequently incorporates iconic ideas from earlier generations of artists in a way that is completely contrary to their original intentions, grounding them back into an everyday reality, and you have to make this very necessary link when you consider what he was doing here . . .
 We had a full, global mail out, which was quite ironic since nowadays everyone gets so much junk mail – especially in the art world where mailing lists are liberally circulated and copied. But Julian's catalogue was so much more 'junky' than art world

junk mail (which actually tries to look rather smart) so it stood out as a nice piece of junk mail and that surprised people... that made them stop and think too.[21]

Opie's approach was characteristically pragmatic:
This catalogue came directly out of what I'd built up as a matter of necessity – my archive, to track my work. I have all these drawing files stored on my computer and when a work goes out into the world I'll drag it over into the archive, which has landscapes, people, faces, animals in it already. I don't want to make a file for each work – I make a page of faces, a page of people standing, something that's tidy, efficient and easy to read.

I like technology and buying bits and pieces, and I had quite lot of these trade catalogues lying around; they arrive in the post (I have no idea where from) and they come in these plastic, difficult to unwrap, vacuum-sealed packages. Once you open them they offer up all this variety. They are pretty badly designed, not great-looking objects, but able to get a lot of information across. In a very straightforward way I felt that I could use the format as a way of structuring an art catalogue. This is something I've done before – with catalogues and with work. That is, I use an existing structure to give me a logic to make something, and to give the viewer a logic to understand it. So you know how to deal with it and what to expect. It made a lot of sense to make this catalogue at the time, and it was quite a simple thing to do: to beef up my archive pages. I looked through a lot of trade catalogues, searching for ways to lay out pages, using background photographs, floating things and then using these graph-like, index boxes for prices and sizes.

There's a very basic human pleasure in seeing something well-described in a drawing. What I've done here is draw a trade catalogue, and in order to get the drawing right I filled it with my own work. I've found that the tighter the circle of logic, the better a work will be. This is a trade catalogue because I'm trading, and it's a catalogue because I'm an artist, and its got my work in it because I'm the person making the exhibition. Whichever way you approach it, it quickly brings you back to the beginning of the circle.

This format also managed to deal with an enormous range of work, and take on a number of aspects: the places where they were shown (the galleries and museums), the price structure and the various manifestations of each image. I think that the reason that I picked the catalogue, rather than the actual show, to be the focus here is because I see it as right at the conceptual centre of my activity at that time. The work was

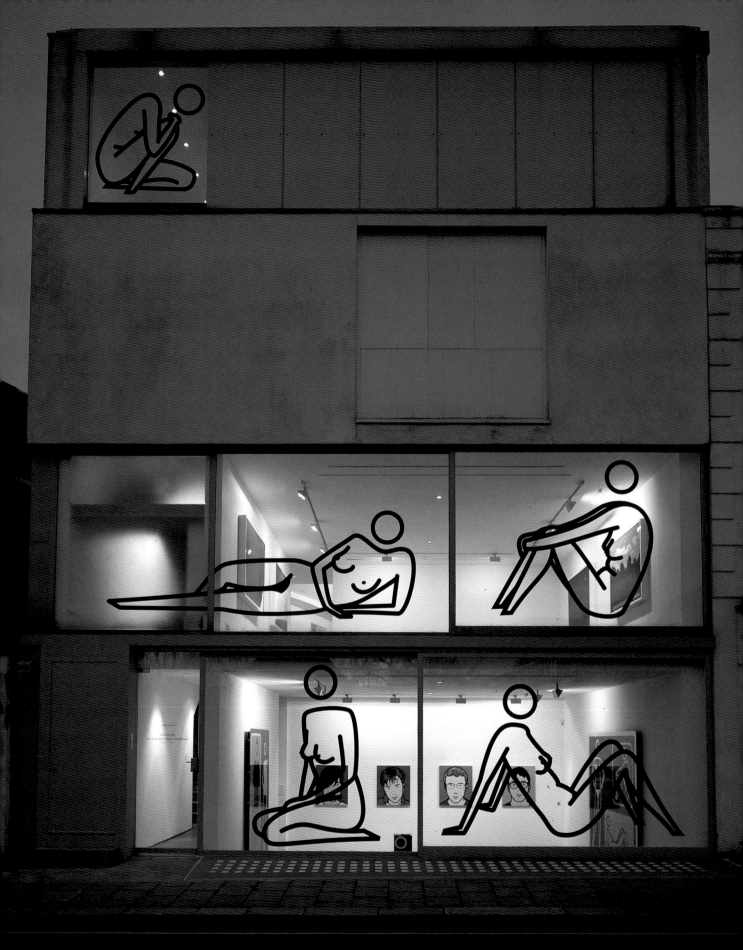

JULIAN OPIE - SCULPTURE, FILMS,
PAINTINGS 2001 [74]
Installation, Lisson Gallery, London

overleaf: JULIAN OPIE – SCULPTURE,
FILMS, PAINTINGS 2001 [75]
Lisson Gallery exhibition catalogue

expanding beyond what one show could deal with. The catalogue shows you much more than the exhibition ever could. It functions like an artwork, and gives you a clear idea of all the different avenues I was developing, all the options I was playing out – but in a disguised way.

Of course, to make the catalogue just right it was necessary to go even further than I'd planned or envisaged, or than was wise even, because, if you're going to have a trade catalogue, you have to have the prices in it. Without it, the drawing would be incomplete – a trade catalogue without prices in it is just not right. So I put the prices in, and it felt exciting, and a bit risky. It's reality, though. It's in people's heads when they go to commercial galleries that the work is for sale, and I wanted to make this a powerful element, a useful element, not hide it. There was also a definite desire on my part to systematise the prices, especially as I was working more and more with different people in different places. I did want to demystify everything perhaps, but the joy of drawing was really the point of looking directly at something and drawing what you see.

The catalogue obviously looks like it's fictional but it is actually real, and that's how a lot of my work functions. A play between revealing the falseness and falsifying the realness, this catalogue is an extension of that, actually tying together a lot of the work and finding a form outside of the gallery to make work and talk about it.

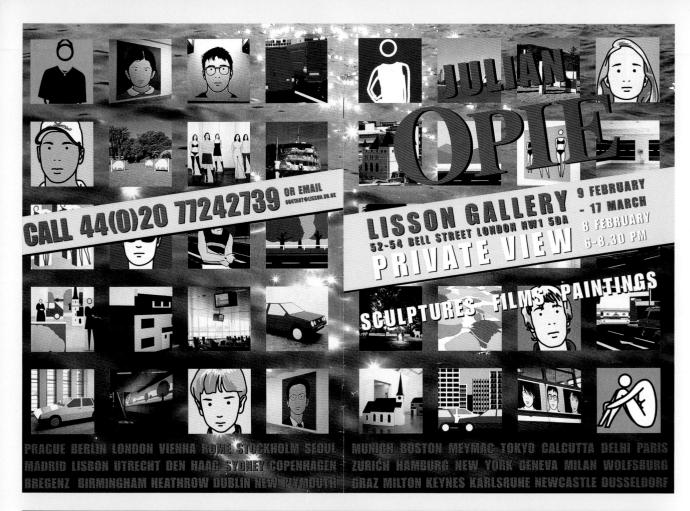

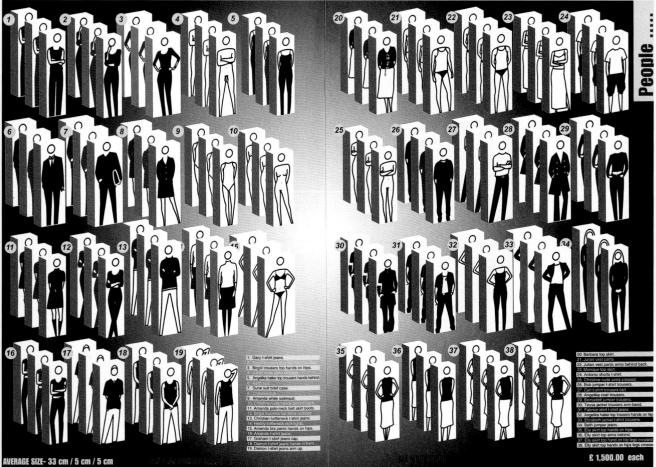

People

1. Gary t-shirt jeans.
2. Birgid trousers and top hands behind.
3. Birgid trousers top hands on hips.
4. Angelika halter top trousers hands behind.
5. Keith suit.
6. Sune suit brief case.
7. Christine suit.
8. Amanda white swimsuit.
9. Christine nude hands behind back.
10. Christine nude hands behind back.
11. Amanda polo-neck belt skirt boots.
12. Birgid trousers top arms crossed.
13. Christian turtleneck skirt jeans.
14. Heddy turtleneck skirt tights.
15. Amanda bra pants hands on hips.
16. Amanda t-shirt jeans.
17. Graham t-shirt jeans cap.
18. Damon t-shirt jeans hands in front.
19. Damon t-shirt jeans arm up.
20. Barbara top skirt.
21. Julian vest pants.
22. Julian vest pants arms behind back.
23. Monique top skirt.
24. Antonio shorts t-shirt.
25. Christine nude arms crossed.
26. Bob jumper t-shirt trousers.
27. Carl t-shirt trousers belt.
28. Angelika coat trousers.
29. Bernadett jumper trousers.
30. Tessa jacket trousers arm-band.
31. Fabrice shirt t-shirt jeans.
32. Angelika halter top trousers hands on hips.
33. Elizabeth jacket t-shirt trousers.
34. Beth jumper jeans.
35. Elly skirt top hands on hips.
36. Elly skirt top arms behind.
37. Elly skirt top hand on hip legs crossed.
38. Elly skirt top hands on hips legs crossed.

AVERAGE SIZE- 33 cm / 5 cm / 5 cm

£ 1,500.00 each

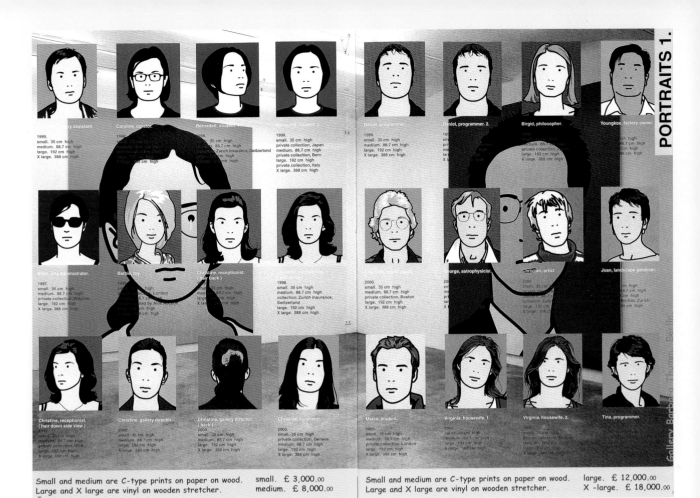

Small and medium are C-type prints on paper on wood.
Large and X large are vinyl on wooden stretcher.

small. £ 3,000.00
medium. £ 8,000.00

Small and medium are C-type prints on paper on wood.
Large and X large are vinyl on wooden stretcher.

large. £ 12,000.00
X -large. £ 18,000.00

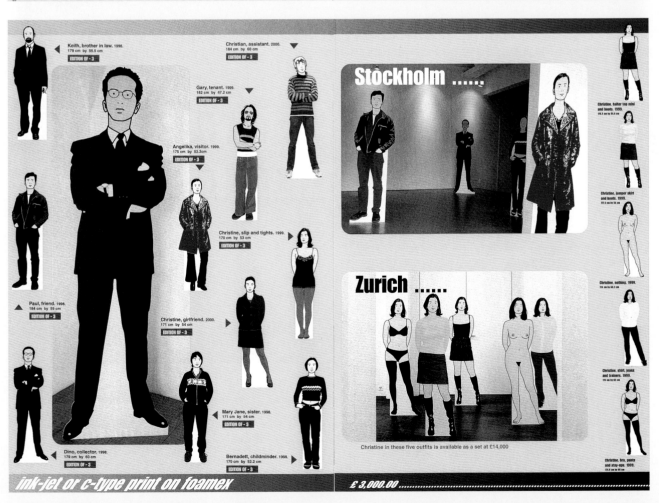

ink-jet or c-type print on foamex

£ 3,000.00

PUBLIC WORKS AND MULTI-MEDIA

Opie has often stated that his intention is to combine and manipulate existing languages rather than invent new ones. His imagery thus never quite loses its origins in the public world – from mass media and advertising to the signs in everyday use – and he actively enjoys integrating his art back into this arena, highlighting the differences and similarities between them, and allowing context to alter and add meaning. Opie is continually testing out different agencies and contexts for his art, whether through designing CD covers or making sculptures for corporate lobbies, and one of the most useful and effective outlets has been in the medium of print.

Artist's Books

Opie has always been reluctant to make straight-forward exhibition catalogues, as his publication for the Lisson Gallery in 2001 demonstrates. He says: 'Whenever I make a catalogue I try to think of some other form of printed object I can mimic. I don't want to make another art catalogue.' He uses catalogues to explore ideas about the presentation of images and on more than one occasion has adopted a model from the real world. His catalogue for the Kohji Ogura Gallery in Nagoya in 1991 coded, classified and reproduced each object within a prosaic, functional format reminiscent of a trade brochure, and his publication for the exhibition *Paysages* at the Galerie de l'Ancienne Poste in Calais mimicked the format of a plastic photograph album – the kind that might have been bought at any high street store. These books are objects of aesthetic contemplation in their own right. They also provide a functional frame through which we can engage with the art. Opie plays with this idea of functionality, pushing us towards a more utilitarian way of looking at things.

Following this logic, he has also made children's picture books – as with *Driving in the Country* for CCC Tours – an obvious and pragmatic extension of his interest in the imagery that is necessarily basic in order to instruct children how to deal with the world. More recently he made a simple flick book, *Daniel Yes, Christine No,* to coincide with a show at the Städtische Galerie, Munich, in 1999. Here, Daniel and Christine are on facing pages of a book, and as one flicks through it one animates images of Daniel nodding and Christine shaking her head. It is a wonderfully basic form of animation, a child's game. We recognise where it comes from and understand it, but the ground is always slightly shifting: we know that this is Opie's project, but is this an artist's book or a child's book? All these publications require the reader/viewer to engage with them actively and imaginatively on more than one level. Opie's trade catalogues and picture books, like his calendars, photo album and stamp sets, are all treated as an opportunity for his art to enter the 'real world' in an inconspicuous way. Of course, this goes against what might be expected in the context of high art, but that is part of his plan. As he has made clear, he wants us to accept something as real while being fully aware that it is a fiction.

Beyond the Gallery

Opie is an artist who seeks out the impersonal and the neutral, and finds great potential in the anonymous public spaces that have become ubiquitous in contemporary life. Considering this, and the fact that he has devoted so much time and energy to constructing an infinitely versatile system for making and showing work, it seems fitting that his public projects and commissions have assumed an increasingly important position in recent years. Opie explains:

6

FIVE SUBURBAN HOUSES 1994–5 [77]
Stone
5 buildings: 129 x 96 x 181
(50 ³/₄ x 37 ³/₄ x 71 ¹/₄) each
Installation, Annonciades, Bordeaux
Commissioned by FRAC Aquitaine

TOWER BLOCKS 1995 [78]
Plaster
12 parts: 63 x 50 x 73 (24 3/4 x 19 5/8 x
28 3/4) approx. each
Installation, The Economist Building,
London 1997

MY BROTHER'S OFFICE 1997[79]
Aluminium and plastic
3 parts: 150 x 300 x 66 (59 x 118 1/8 x
26); 150 x 300 x 66 (59 x 118 1/8 x 26);
250 x 66 x 66 (98 1/2 x 26 x 26)
Installation, *New Pieces*, De
Gouverneurstuin, Assen 1997

IMAGINE YOU'RE MOVING 1997 [80]
Lightbox and computer installation,
Heathrow Project, London 1997
Commissioned and funded by
BAA Plc as part of the BAA Art
Programme in association with the
Public Art Development Trust

Galleries are a fairly recent invention and so are museums of art. Before that there were other ways for artists to get their work across, from designing coins to painting the ceilings of churches. I've always been very interested in trying to expand on ways of showing art, in terms of making films, sound pieces, or using any means to get the work across.

Opie's visual language is accessible and highly legible, and as such it can deal with different kinds of audiences, and infiltrate non-art locations without incident:

I think one often underestimates people. Visual information is complex, particularly in towns... Everyone is constantly facing thousands of fine distinctions ... My work is designed to force you to appreciate it . . . Appreciation in terms of reading it . . . being drawn into playing the game.[22]

Opie's earliest public projects had their roots in the works he had been making for galleries, and this has set the tone: he treats public commissions as a way of developing existing ideas. One of his first significant commissions was in 1994 when he transposed views of *Imagine you are walking* onto walls at Wormwood Scrubs Prison. Opie found the experience of working in this sterile environment challenging:

I was very conscious of what it meant to make a work at Wormwood Scrubs. With any commission you have an audience who might resent what you're doing – they might not want art thrust upon them. I was dealing with a very loaded situation.

The paintings were sited at regular intervals along the perimeter wall, in an area that no-one could physically access. In terms of scale, these murals are carefully proportioned (3 x 4 m), so that if someone were to stand against one, it would look as though they could enter the space of the picture and thus escape. As Richard Dorment wrote:

Opie is using the science of perspective as a metaphor for freedom. The illusion of space is shown to be the visual equivalent to the illusion of escape. The ground plan of each mural is in fact different, but spatially the scenes are similar enough to confuse the viewer into feeling that he has been down this or that cul-de-sac before. We become like prisoners turning over and over in our minds different avenues of escape, but always coming up against the hard reality of our situation.[23]

Opie often disguises his artwork in the public domain; through the careful choice of materials, he ensures that his work speaks the language of the environment in which it is found. *Cinq bâtiments de Banlieue* ('*Five buildings in the Suburbs*') 1995, another permanent commission, demonstrates this neatly. Sited in the beautiful cloisters of Annonciades in Bordeaux, it consists of five stone blocks placed on the lawn with a gravel path winding between them. As understated stone structures they blend in with their surroundings. Each block is in fact a simplified model of a suburban housing unit, with indentations to suggest doors and windows. They also resemble tombs and were based on the small houses built for the dead that Opie had seen in Italian grave-yards. As representations on several levels, they are estranged from yet somehow still complement their surroundings.

Another example of this approach is *My Brother's office*, metal sculptures of tower blocks first sited in a town park in Assen in 1997. Opie explained:

The park is well kept but informal and small, near the centre of town ... I wanted the sculpture to be very dumb and straightforward, like a motorway sign for offices, but so familiar in its look and configuration that it seemed realistic. I wanted the physical qualities of a Seventies metal park bench ... I wanted to annoy by evoking the ordinary urban work place that the classic city park tries

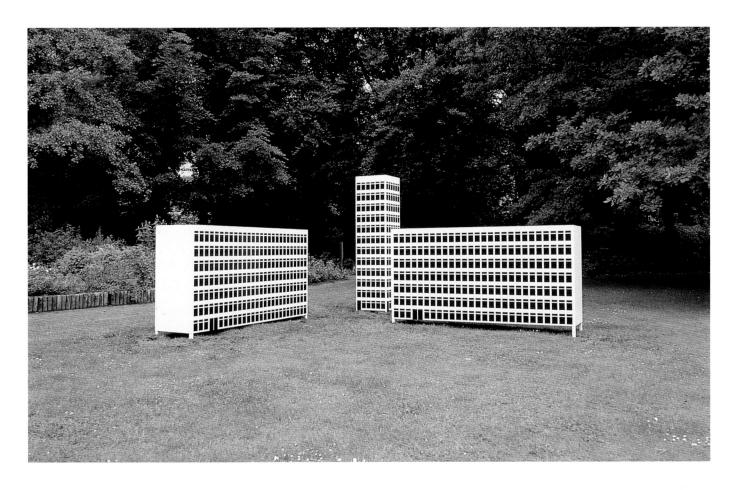

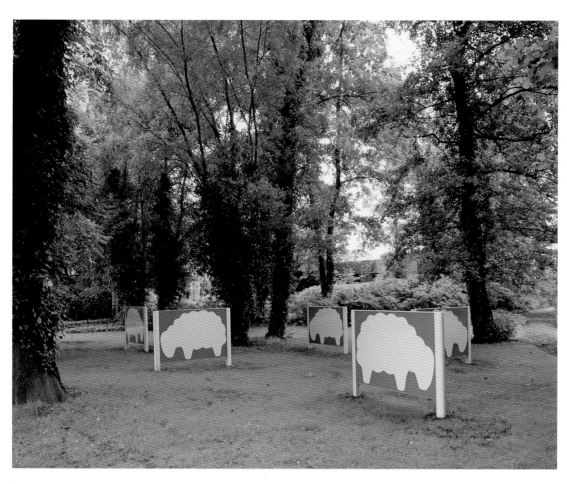

MY AUNT'S SHEEP 1997 [81]
Aluminium and plastic
5 parts: 150 x 100 x 8
(59 x 39 ³/₈ x 3 ¹/₈) each
Installation, *New Pieces*, De
Gouverneurstuin, Assen 1997

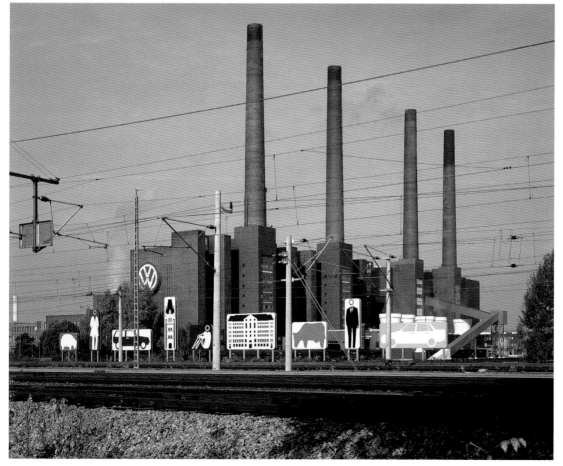

SMALL TOWN 2000 [82]
Installation: Wolfsburg, Germany
2000
Steel, aluminium, paint, vinyl

to forget or hide, but I wanted to please by making a nice drawing of something familiar.[24]

When commissioned by the Public Art Development Trust to make a permanent installation for the new Flight Connections centre at Heathrow airport in 1997, Opie again chose to integrate the work into the fabric of the building. The project, which was called *Imagine you're moving*, has two significant elements: four light boxes that occupy the atria in the centre and run almost continuously along the length of the space, and video monitors in the waiting area. Because the centre caters for passengers making connecting international flights through Heathrow and who never go outside the airport, Opie decided to reintroduce the idea of the English landscape in this sealed-off, artificial environment. He condensed the canonical images of English landscape tradition – combining such disparate sources as John Constable, Capability Brown and Thomas the Tank Engine – in a series of simplified landscape views, shown on the monitors and light boxes. The flat, idealised landscapes with their trees in full leaf, green hills and blocked-in sky are simple and direct enough to be taken in quickly, reflecting the transient experience of the traveller.

The light boxes suggest a giant window through which to view the outside world. Most passengers would see them from the escalators, either descending or ascending, so the landscape is static but the viewer is moving, recalling the experience of taking off or landing in an aeroplane. In the transfer lounge waiting area, the same landscape view moves slowly past us, screened on video monitors where we might expect to read flight information. Opie noted: 'It is as if these objects had taken time off from their normal functions to reflect the experience of the passengers.'[25] By working with the existing technology of airport signage and advertising, Opie's manoeuvring is quiet and considered. The bright, artificial colours of the landscapes are illuminated by fluorescent light, presented in a way that perfectly replicates the formal clarity of advertising.

In this instance, the visual effects of backlit vinyl fed into subsequent projects, and Opie acknowledges how public commissions have given him access to new materials, new methods of fabrication, and new modes of presentation, all of which contribute to his works-in-progress. Actual road signs were the unexpected outcome of a public commission initiated by Volkswagen in Wolfsburg in 2000. Here, Opie inserted an array of imagery into the skyline of the city between the railway line and the VW Factory. People, animals, cars and buildings were drawn on a vector computer programme, fabricated in vinyl, applied to metal signs and arranged along the banks of a canal. Glimpsed from across the water, these huge road signs vaguely fit with our expected experience of the city, although obviously the location seems curious. Like the backlit vinyl, road signs are now part of Opie's system, and have since found their way into his gallery installations, notably in his solo show at the Ikon Gallery in Birmingham in 2001 and outside Tate Modern in 2002.

Animals were introduced into Opie's repertoire of images in 1997, initially inspired by a set of Viennese toy farmyard animals. Opie felt at ease adding animals to his sign language: 'Animals in some ways are already close to symbols. They are so symbolic anyway – we might see a road sign for a deer or hedgehog more often than we see a real one.' Rendered as a clean, perfunctory outline, child-like and familiar, they were grounded in this 'Early Learning Centre' aesthetic as much as the language of the Highway Code. As we have seen time and again,

an overtly manipulated reference to reality underpins Opie's artwork. The authenticity of these images is confirmed by our experience of the real thing as well as by our experience of existing mediations of this reality. The sheep are doubly familiar in that they are just like sheep grazing but they are also like road signs:

The drawing may be a sheep but the structure is more like a sign. It looks like I wanted images of sheep there amongst the trees and used an obvious and common technology to do it, but their form as sign undermines the pastoral quality of the representational sheep. The final impression is neither sheep nor sign, but a visual proposition, an abstract drawing using the real world as its material and aiming at least to incorporate the surrounding reality into its own logic.

There is something familiar and reassuring about *My aunt's sheep* (first shown in the park at Assen in 1997 and subsequently in the Royal Botanic Gardens for the Sydney Biennial in 1998). By placing sculptures of animals in green urban space, Opie was fulfilling one set of expectations, reflecting on our common desire to see nature flourishing in the modern cityscape. In Sydney, the way in which the sheep were pictured grazing in front of the Harbour, with the Opera House and the bridge behind them, was picture-postcard perfect. Since everything seemed to be in the right place, designed to make the viewer feel at home, a sense of reverie, however strange, attended an encounter with these animals. The fact that they are 'my aunt's sheep' and not just any 'sheep' also communicates a feeling of affection and grounds them in something personal, much as with *My brother's office*.

Opie has used animals in other urban spaces to great effect. In 1997 in Bregenz, Austria, he showed *Sheep Cow Deer Dog Chicken Cat*. Being three-dimensional cut-outs painted in bright, primary colours, these animals bring to mind both small models made for toy farmyards, and also those larger playground wooden animals designed for children to ride on. Once more, the sculptures refer to a reality already mediated by representation. Thus, a basic symbol carries a complexity of meanings, but the connection to childhood maintains a comforting sense of nostalgia. The animals reflect Opie's desire to create intimacy in public spaces and break down barriers. Humour also does this, since the animals are kitsch and obviously not to be taken too seriously. *Three Shy Animals* 2000, installed at Clissold Park in Stoke Newington, is again reassuringly familiar – acrylic signs of a rabbit, a deer and a fox. They may be 'wild' animals but they look attractively quaint. Illuminated with fluorescent light they emit a gratifying glow at night, encouraging a sense of community in the midst of urban parkland, but consciously failing to compensate for the loss of the original.

In recent times there has been much debate about the predominance of brands and logos in the contemporary landscape. The metropolitan eye is increasingly accustomed to absorbing a myriad of signs. Making an image that can communicate on varying scales and in different formats, that is bold and provocative, that can float free of mere products, is a driving concern in the world of advertising and graphic design. Opie knows well the seductive power of signs and has always been interested in this world, freely appropriating its tools and technology, his serial modes of production both echoing and competing with the world of commodities.

Opie has invoked the idea of the logo when discussing his digital portraits, and these are effortlessly translated into a diversity of formats:

I DREAMT I WAS DRIVING MY CAR
(COUNTRY ROAD) 2002 [83]
Inkjet on vinyl
Installation, St Bartholomew's
Hospital, London

MY GRANDFATHER'S GRAVE 1997 [84]
Concrete
11 parts: 160 x 76 x 8
(60 x 29 7/8 x 3 1/8) each
Installation, *New Pieces*, De
Gouverneurstuin, Assen 1997

overleaf: SHEEP COW DEER DOG
CHICKEN CAT GOAT 1997 [85]
Oil-based paint on wood
Installation, Roche Court, 2003

from left: ALEX, BASSIST; DAMON,
SINGER; DAVE, DRUMMER; GRAHAM,
GUITARIST 2000 [86]
C-type print on paper on wood
88.7 x 75.9 (34 $^7/_8$ x 29 $^7/_8$) each
Installation, Lisson Gallery, London

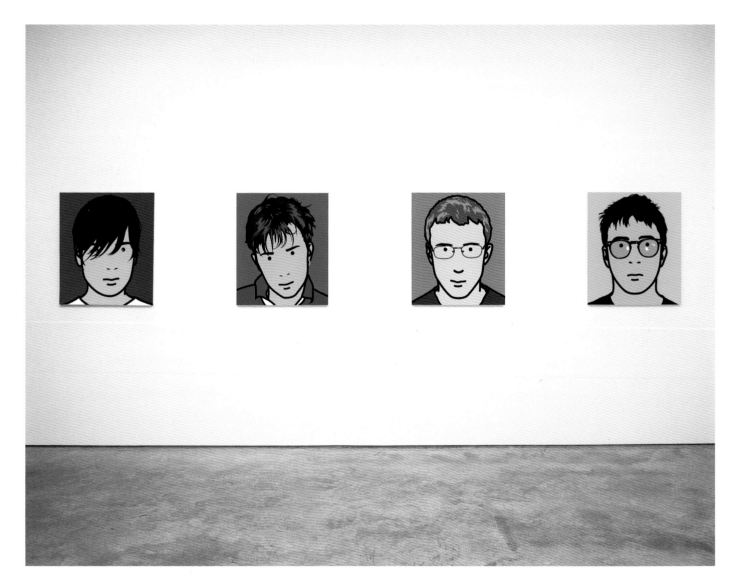

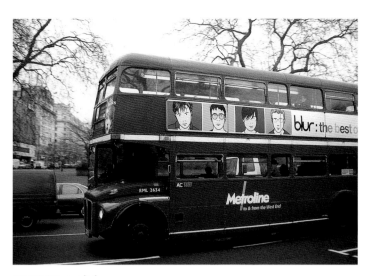

BEST OF BLUR 2000 [87]
Poster, London

reproduced on the pages of a magazine, shrunk to the size of a postage stamp, or enlarged as a poster on a construction hoarding. In 2000, the magazine *Sleazenation* printed one on its cover and a series inside, all appearing full page, without explanatory text. They caught the attention of a design group who had been asked by EMI to suggest possibilities for the 'Best of Blur' album cover. Opie was commissioned and began by making digital portraits of the four band members. With each portrait he abstracted and refined the image in his now trademark style, and captured, by an economy of means, the most succinct likeness. These 'generic icons' could translate into multiple formats and scales for various recording format covers, billboards, bus posters, t-shirts and mugs. It became Opie's most far-reaching project. Making images to billboard scale shifts them into the public arena of mass advertising. Mounted overhead, the pictures work as subjects of wide-ranging communication, and communicate they did. But although Opie enjoyed seeing his work in this new context, this was not his guiding motive, and the actual portraits became part of his on-going inventory and were soon to be acquired by the National Portrait Gallery in London. To find the same image on a CD cover, a billboard, and in a national museum, is a fairly unique proposition.

Opie's vision is elegant but not rarefied. Having taken so much of the inspiration for his early work from the constructed communal spaces of the shopping centre, the corporate office and the airport terminal, it seems logical that these very places should now offer an outlet for the presentation of his work. Public commissions also empower Opie on a practical level to make work that has high production values and uses the very latest technology. Reflecting and utilising the elements, objects and methods of the commercial environment is now integral to his creativity, and this strategy allows his art to access an expanding field of culture, and to be dispersed through a rich variety of media. Opie is a prolific and restless artist, exploring the potential for each idea, and this invariably means that he will continue to push his art into new territories.

Throughout his career, Opie's core concerns have remained unchanged. As this survey shows, he has worked his way through an exhaustive range of ideas, materials and conceits, and produced a number of clearly defined and quite distinct bodies of work. But at the heart of this is an enquiry into the meaning of everyday objects and their representative power. From the early metal cut-outs to the hard-edged utility units, from the partitions and booths to the graphic sign language he uses today, Opie teases out the ambiguities between object and image, between the literal and the illusory, and encourages us to enjoy the tensions and uncertainties inherent in the experience of seeing.

Opie is typically understated about his activities, saying: 'I'm simply using that which is available to describe that which is experienced.' But precisely because of the simplicity of his visual language, and the smooth, seductive surfaces of his artwork, his tactics are often deceptive. By stripping things back to basics, Opie is liberating the image from specific meanings. He is undressing each object in the same way that he undresses his standing figures, asking us to approach the imagery afresh, with virgin eyes. The playful reductiveness of his formal language is rooted in childhood. However, this childishness is incorporated into an adult world of seeing.

Through his symbolic language Opie makes us more aware of the unresolved tensions between perception and recognition. With his agile style, he

4 ESCAPED ANIMALS 2002 [88]
Installation: Tate Modern, London
2002
Vinyl and paint on aluminium
Dimensions variable

reduces things to minimum unities, and this welcomes in the arbitrariness and ambiguities of subjective interpretation. His art thus begins a process of questioning.

We now readily accept the facility of images to operate as signs in a shared visual vocabulary. Opie has created new forms of expression using existing modes of presentation, which is perhaps the most difficult task of all. He is not radical in the sense that he rejects the art of the past; rather he has adopted key ideas and used them to his own ends. Nor is he radical in the sense that he set out to subvert the symbols and structures of our standardised and stereotyped contemporary world. In many ways, his strategy is more radical because it is subtler, more surreptitious. He deploys a language that we know and understand, and technology that we encounter daily. But the way in which he uses them causes first hesitation, then curiosity, and the debate begins. Discussing Minimalism, Michael Craig-Martin once wrote, 'Radical art never creates anything entirely new: it simply shifts the emphasis. What previously was unimportant, taken for granted, invisible, becomes central.'[26] This rings true for Opie's oeuvre time and time again.

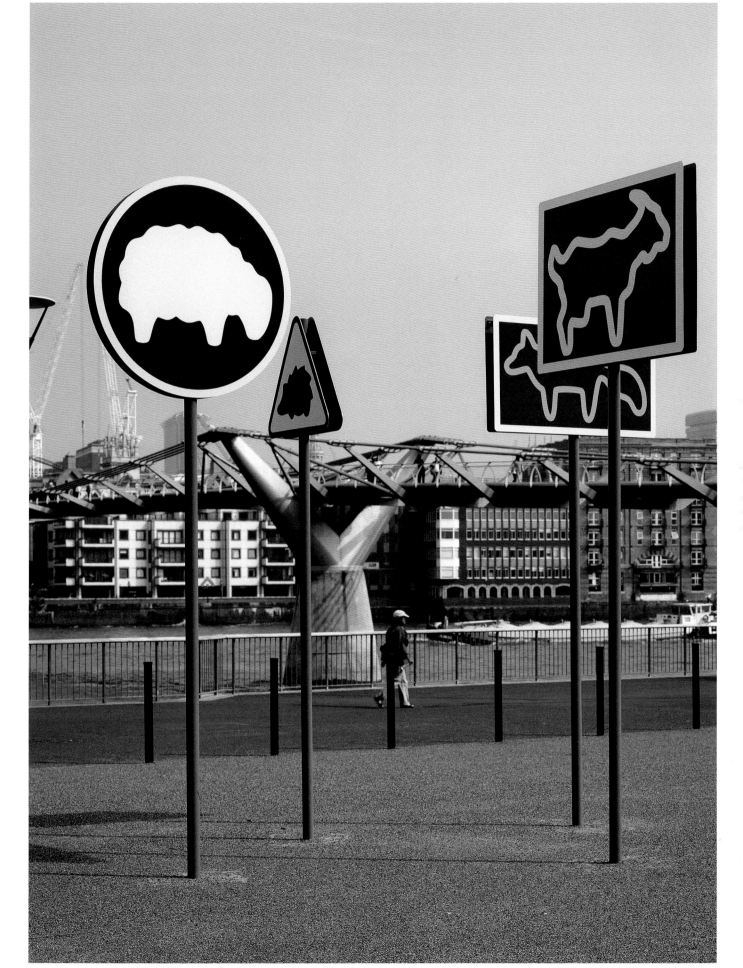

It started as a project for a Jean Nouvel building in Tokyo, which was being built for a big Japanese advertising company. I knew it would be a very busy place, with people arriving from the underground, walking into the building, through the lobby, and waiting for a short while before getting the lift up to their offices. There's a wall of glass lifts that go up at high speed, looking out over Tokyo. It's very high tech and I saw a lot of movement going on in there. I thought I could use this as a camouflage for my work. What I wanted was to infiltrate the scene.

I was also really interested in LED screens, which they use a lot in Japan. I saw these illuminated signs everywhere in Tokyo and Seoul – and the fact that I can't read them makes them much more appealing; the movement and colour is all you see. It's incredibly beautiful, like something in nature, like light on water. The city loses its solidity and becomes a fluid thing, especially at night.

I'd been making drawings of people's faces, and creating various simple movements by layering the drawings, making them blink and nod their heads. I'd also been drawing people in full length, in different positions. Looking at many drawings together, there was movement: flicking across them you get this simple animation. After I'd seen the space, I knew I was going to make statues of people, and I tried to think of a movement that would feel natural there and was simple enough to be looped. Walking fitted the bill: it was simple and familiar. I decided to make three people – three's a good number, the minimum number for a crowd – and I looked for different types in order to create contrast between each.

I tried to use the language of the building; the floor was made of marble so I used marble for the plinths. There are in fact little scrolling LEDs on the lifts. The choice of technology tied my work to the surroundings. And other things happened. What was interesting and unexpected here was how the glass and stainless steel created all these multiple reflections. Every window shows reflections of the moving, lit figures; they stand out from everything else. It animates the whole space in a way that I hadn't really expected. That's the good thing about commissions: you're dealing with new environments and unexpected things happen.

Kiera is a young artist. She's one of the people I call on to draw from time to time. It turns out she has very long legs; I tried her in different outfits, and when she was wearing a miniskirt and high heels her walk became much more particular. I suppose she walked a bit like a catwalk model, but it was only after I'd filmed other people that I noticed these nuances.

I made about thirty drawings for each person. I needed a man so I drew myself, and then I thought I should use another woman, since it's easier for women to look different from each other. The other woman, my wife, is wearing boots and walks in a different way. So there were three very different-looking people, all striding purposefully at different rates, and yet staying in the same place.

The actual movement turned out to be much more realistic than I expected. There's nothing realistic about the image, but that doesn't matter, and, if anything, it heightens the sense that the movement is realistic. The three people are not really to be looked at but more looked through, or around; they're there to animate the situation. When you do look at them you start to notice the lights, and how they work, a bit like when you look at a stone sculpture and you notice the sparkle in the stone, the grain of the marble. This is another level of looking, which is fine and should work, but for me it's not the main thing. The main thing is the movement.

After I'd animated the drawings, I found I could use other technologies, and so I used Kiera Walking *on plasma screens. Plasma screens are quite common now; they're used a lot for public information displays. But I like them because they're flat and can be hung on the wall like a painting. To see an animated image on something so high tech seems completely right; because the image is quite like a sign, this suits one set of expectations, but then the glass screen and rectangular shape fits the idea of a classical painting.*

Kiera Walking *also became a wall work: I had these drawings of Kiera, and if you flick between them and look across them then you read the movement. I had an exhibition in a gallery in Portugal where they had a long hallway. You could see all the way down the length of it, but couldn't get any distance from it. I wallpapered every other frame from the film along this wall, so she mimicked your movement down the hall.*

And I'm now using Kiera and the other people for a project for the new Selfridges store in Manchester, where they wanted a project to animate the whole building. Using vinyl pictures on glass, all three people are depicted walking around the building. The spaces are complicated, and at times the people meet, walk together, and then head off in different directions.
It's a positive thing to see how these images could function in different ways, and I do that with everything. I'm always juggling, turning one thing into another thing, but keeping some elements constant. It would feel fraudulent to come up with another image simply in order to avoid upsetting those people who want something that's specifically for them, like a logo or a brand. For me, the project, the gallery show, the commission, they're all opportunities to work and play out the ideas in which I'm engaged and interested.

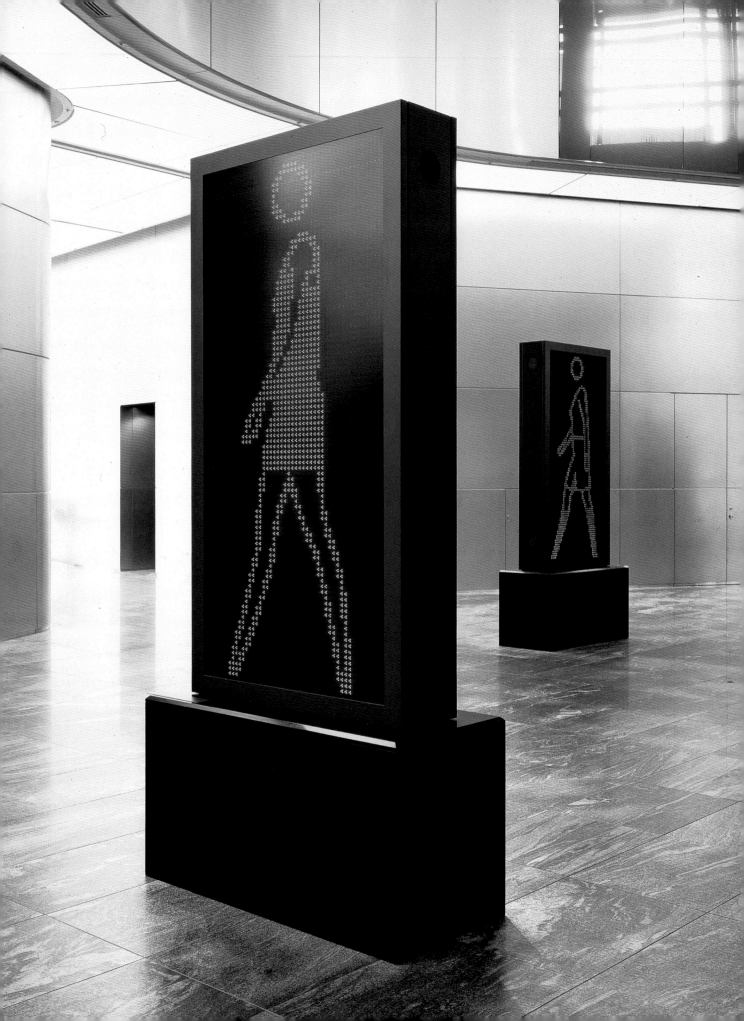

left: KIERA WALKING and CHRISTINE
WALKING 2002 [89]
LED panel
Installation, DENSU building, Tokyo 2002

below: KIERA WALKING 2002 [90]
Wallpaper: inkjet on paper
Installation, Mario Sequera Gallery, Braga,
Portugal

overleaf: THIS IS KIERA WALKING, THIS
IS CHRISTINE WALKING, THIS IS JULIAN
WALKING 2002 [91]
Vinyl
Installation, Selfridges, Manchester

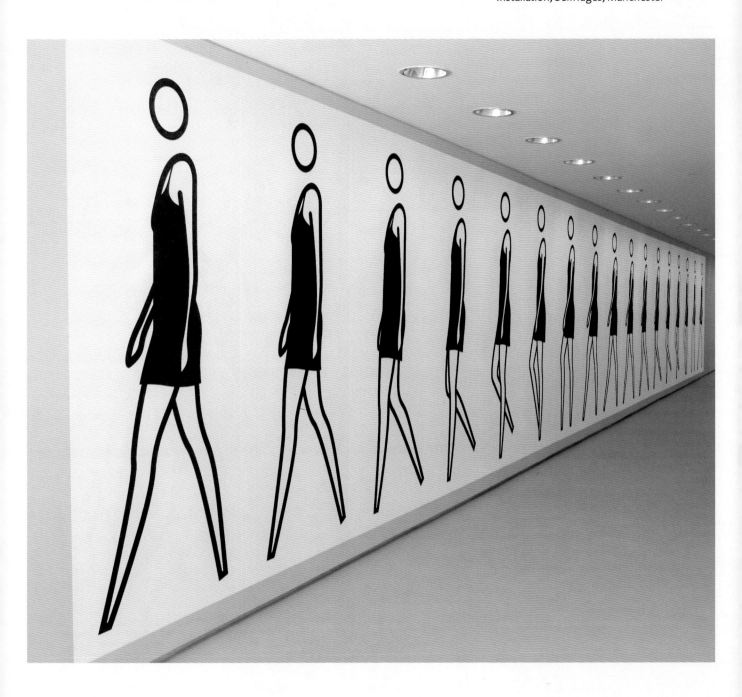

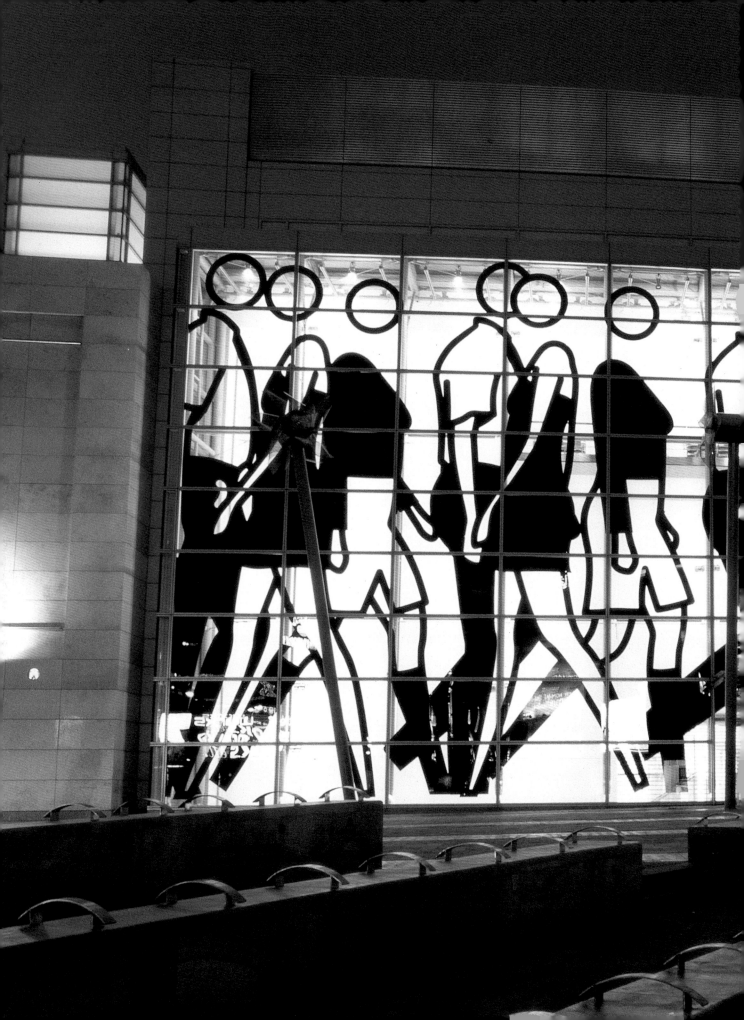

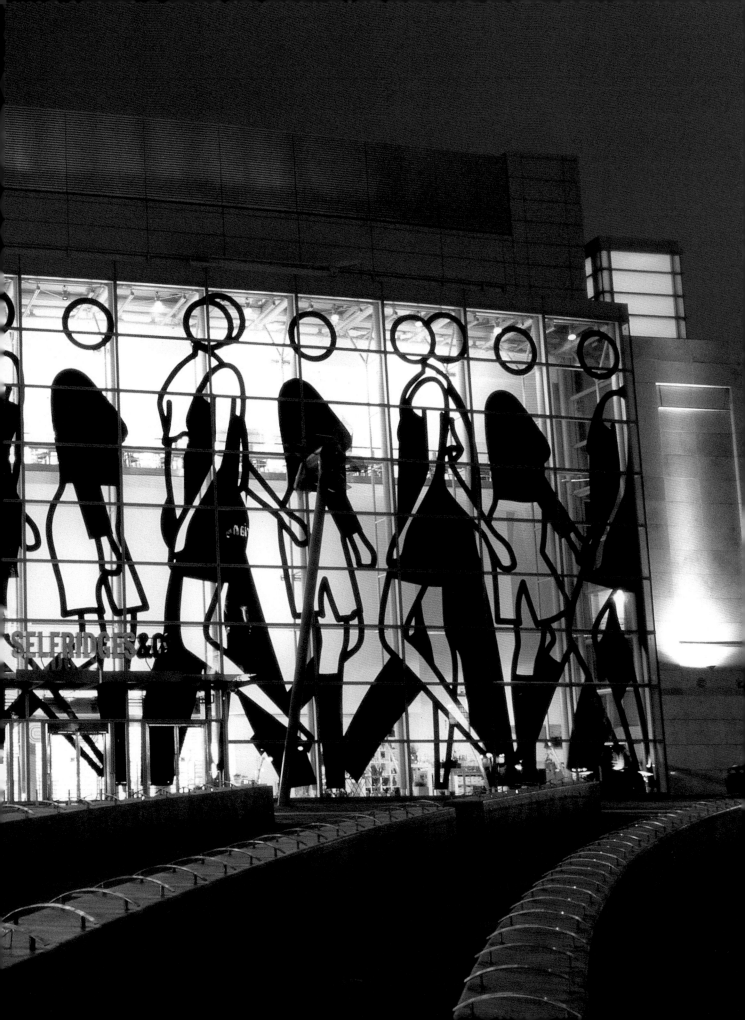

Sometimes he wonders what zone of transit he himself was entering, sure that his own withdrawal was symptomatic not of a dormant schizophrenia, but of a careful preparation for a radically new environment, with its own internal landscape and logic, where old categories of thought would be merely an encumbrance.[27]

Many critics perceive Opie's art as symptomatic of a state of alienation, highlighting how in this world of advanced technologies we have grown estranged and distanced from our own natures. Opie expresses frustration at this reading, not least because it frequently falls foul of a kind of historical amnesia, ignoring the way in which artists and writers from the seventeenth century onwards have used detachment as a tool to explore how we relate to the world. Opie also questions why this state of estrangement is generally portrayed in such negative terms, and points out that his tone is never so despairing. Of course, there is no denying that the onset of modernity did bring a growing sense of anxiety, and that many artists reflected this in their work. On the continent, writers such as Baudelaire saw the city as the catalyst for individual alienation, and described how metropolitan life, with its anonymous crowds and newly scaled spaces, would overwhelm and alienate us. In Britain, Dickens and Ruskin predicted that industrialisation would distance us from nature and leave us spiritually bereft.

Skipping forward to the present, we accept the reality that is modern technological and capitalist development (the shift from Metropolis to Megalopolis). Our world is one of accelerated movement, overabundant information, virtual parameters of scale, the proliferation of signs. As representations of reality supplant reality itself, everyday experience is increasingly about a fast-paced flow of images. Artists like Opie are trying to find a new way to deal with this.

When the anthropologist Marc Augé published *Non-places – introduction to an anthropology of supermodernity* in 1995, transience was a key characteristic of the world he described:

where people are born in the clinic and die in hospital, where transit points and temporary abodes are proliferating … where a dense network of means of transport which are also inhabited spaces is developing; where the habitué of supermarkets, slot machines and credit cards communicates wordlessly through gestures with an abstract, unmediated commerce; a world thus surrendered to solitary individuality, to the fleeting, the temporary, the ephemeral.[28]

Society is in flux, buffeted by a constant flow of information and of people. Our lives are channelled through road, air and rail routes, around airports, service and railways stations, dependent on invisible and interconnecting cable and wireless networks. Augé believes that we do not yet know how to look at this world; it is in fact a world that we read rather than look at, a world through which we pass at speed.

Speed drastically altered our perception of the landscape. In the early twentieth century the Futurists pushed the celebration of modern technology to an extreme, proclaiming a new aesthetic of speed. Their leader Marinetti edged towards insanity, with his fantasy that the acceleration of life would straighten meandering rivers and that someday the Danube would run in a straight line at 300 kilometres an hour. The Futurists' romance with machines and their remoteness from society resurfaced (albeit in a new guise) in the inter-war 'machine aesthetic' of the Bauhaus, Mies van der Rohe and Le Corbusier.

PORTRAITS 1999 [92]
from left: GARY, POP STAR; DINO, GALLERIST; BERNADETTE, STUDENT; KEITH, MECHANIC; WALTHER, PUBLISHER; ELENA, SCHOOLGIRL
Cut vinyl
Installation, Tate Britain, London 2000

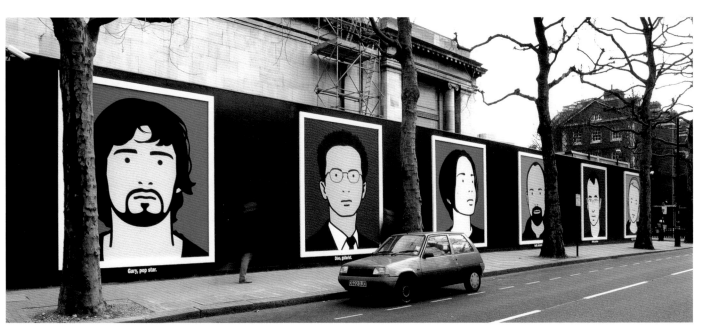

Now Opie, much of whose art is inspired by the idea of travel and motion, has updated this concept with his own evocation of car culture, *Imagine you are driving*. Significantly, however, the emphasis has shifted. Opie presents us with an endless sequence of images of the road ahead: we have less of a sense of the inspiring and exhilarating pace of movement, and more an expression of the anonymity and monotony of motorway travel. But the obsessiveness of the depiction is compelling. We fix on the white lines marking the tarmac, propelled by the vanishing point towards a horizon we never reach – drawn into a kind of spatial sublime. Opie captures the real effects of driving, how the car both liberates and distances us from the world – so that we pass through the landscape quickly and are closed off from direct experience of it. The sights, sounds, tastes, temperatures and smells of the material world are reduced to the two-dimensional view through a windscreen. Of course, this view is a succinct metaphor for contemporary experience: seeing the world through a screen. The technologies incorporated within the car reinforce the artificiality of this experience: we find ourselves in a sealed, stable, weightless environment. With our senses impoverished and our bodies fragmented, we begin to dream. This is what Opie feels. When we drive through the city, the streets and buildings become the backdrop to our thoughts, virtual passages through which we move, on the way to another place.

The signs and texts planted along the motorway tell us about the landscape through which we are passing, making its features explicit. This fact might enable us to relinquish the need to stop and really look, allowing us to retreat into reverie. Because we are constantly on the move we are always in a state of distraction, having to deal with a barrage of visual and social stimuli (signs, slogans, billboards, lights, fumes, sirens). Have we learned to overlook subtlety and detail?

Opie's *Cityscape* 1998 is an audio recording of a journey through London by car. In it, he and fellow artists Lisa Milroy, Richard Patterson and Fiona Rae recorded what they saw en route, each of them focusing on a specific subject category. Opie listed the brands of cars seen ('Honda', 'Fiat'), Patterson identified building types ('Shop', 'Bank', 'House'), whilst Rae read from posters and billboards ('Buy your specs here', 'North to Watford') and Milroy described people glimpsed along the way ('Man with hat', 'Woman with handbag'). Read one way, the work shows that we are unable to assimilate everything that surrounds us; that we reduce what we do see to the essentials in order to negotiate our way. But there is a flipside: the abstract flow of words can be as evocative as actual images. Listening to them, we conjure mental images fairly effortlessly. The mind's eye can take over.

The philosopher Freddie Ayer was once asked which single thing he found most evocative of Paris. The venerable logical positivist thought for a while and then answered: 'A road sign with Paris written on it.'[29]

Opie often talks about how we 'read' images, and his language of signs has a fictional functionality. He acknowledges that perception is increasingly about recognition, and recognition is triggered by the most simple things. His imagery is perfunctory but this is not a critique of how life is reduced to a surface and a symbol. Opie accepts what is out there and attempts to create something new and meaningful with it. In this enterprise, he is not alone.

Motorways allow us to escape mentally as much as

WE SWAM AMONGST THE FISHES
2002 [93]
Installation, MCA, Chicago

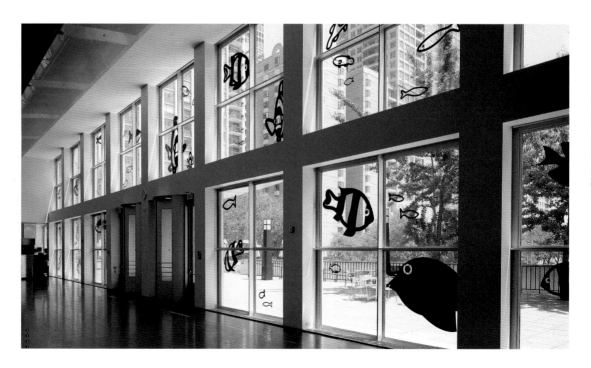

physically, and the fact that most video games are about driving seems to support this (interestingly, 'M25' is both a video game and a brand of ecstasy). The weightless mobility of driving inspires imaginative travel. In the writings of J.G. Ballard, the rediscovered literary hero of current times, the sense of estrangement and uncertainty that came with new technology and the onset of car culture is a pivotal theme. Novels such as *Crash* or *Concrete Island* (first published in the early 1970s but now enjoying cult status) are condemnations of automotive alienation yet also celebrations of technological achievement. In *Crash*, the car becomes an extension of the human body, surrounding the soft and vulnerable human skin with a shell of steel. Ballard relishes the exultant sense of freedom and detachment that driving generates. He believes that we must embrace this condition, and that only then can we learn what lies beyond it. In this sense, Ballard and Opie think alike.

Motorway travel is no longer a novelty. However, the motorway has come to occupy a prominent position in the collective psyche; its very ordinariness and neutrality have allowed it to be interpreted as a potent psychological space. As Michael Bracewell notes:

Increasingly, as the motorway features in the reclamation of shared and formative memory for successive generations, so its initial cultural status as a non-place is being exchanged for a new measure of significance.[30]

A re-assessment of the cultural status of roads and their hinterlands is under way, made plain by the recent wave of publications such as Edward Platt's *Leadville: A Biography of the A40* (2000) and Iain Sinclair's *London Orbital* (2002). In the latter, Sinclair attempts to walk around the vast stretch of urban settlement bounded by the M25, the 120-mile road that encircles London. The resulting book is a dense and complex meditation on urban sprawl, the effect of automobiles and modernity. It reveals a side of London that is often ignored, merging history and memory, fact and fiction. Significantly, when Chris Petit chose to make a film based on the book, he drove around the M25, filming the view from his windscreen. He wanted to capture the hallucinatory quality that driving can create, finding this to be the proper visual equivalent to Sinclair's writing.

The service stations that line our motorways and punctuate our journeys – corporate, neutral and standardised – have also been given a new frisson of significance. As Augé observes:

most of those who pass by do not stop; but they may pass again, every summer or several times a year, so that an abstract space, one they have regular occasion to read rather than see, can become strangely familiar to them over time.[31]

Such spaces might summon the residue of childhood experience or provoke a general sense of nostalgia. In his book, *Always a Welcome – the glove compartment history of the motorway service area 2000*, David Lawrence sees the service station as an 'ephemeral and ever-changing micro-landscape',[32] a site of work, leisure and social intercourse that now occupies a central position in our everyday lives. And so the 'non-place' gains ground. Opie has already identified the potential romance of such spaces. When asked to make a sculpture for Belsay Hall in Northumberland he made *Rest Area* 2000, a supermodern sanctuary of steel and glass that brought together elements of a Greek temple, an eighteenth-century folly and a petrol station – a service area Utopia in a beautiful woodland setting.

REST AREA 2000 [94]
Steel, glass, electric light
225 x 284 x 366 (88 5/8 x 111 7/8 x 144 1/4)
Installation, Belsay,
Northumberland

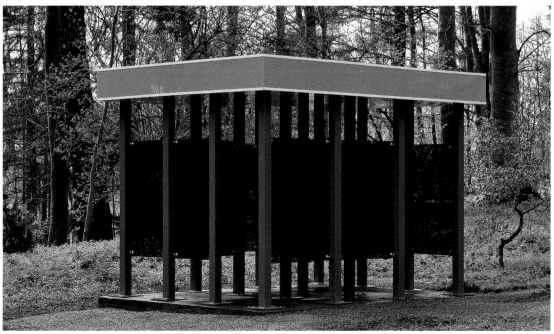

Bracewell concludes that this new concentration on 'boring places' is connected to the emotional needs of a generation now out of patience with post-modernism. He may be right.

When Augé writes of the 'non-place' the key location he has in mind is the airport. From the artificial spaces of motorways and service stations we might make an easy transition to the airport departure lounge. Aeroplanes ushered in a new age of accelerated global travel, and like the motorway they were full of promise, once emblematic of an idea of the future. The psychological implications of flight – a sense of vertigo, feelings of disorientation – might worry some travellers, but this is regularised in the modern airport through mechanical and highly controlled flow of traffic. The anonymity of the airport – its brilliantly lit, multi-reflective interiors and gleaming passageways – can induce a sense of generalised estrangement. Closed off from climate change and the cycles of natural light, the airport is an optically static environment in which we become physically desensitised. When reviewing one of Opie's exhibitions the critic Andrew Graham-Dixon wrote:

Opie's work … knows the blend of pleasure and alienation that somewhere like Heathrow can provide. Moving through an installation of Opie's is like moving through a modern airport: it is to feel both pleasantly and unpleasantly removed from reality, in a zone of transit where what you do or who you are has become both threateningly and relievingly unimportant.[33]

That Opie wold then be commissioned to make work for Heathrow's Terminal 1 makes Graham-Dixon's words even more apt.

Ballard lives in Shepperton, a suburb close to Heathrow. He eulogises this airport for 'its transience, alienation and discontinuities, and its unashamed response to the pressures of speed, disposability and the instant impulse.'[34] His narrator in *Crash* also lives near an airport, and the novel is set in its concrete landscape. For Ballard, flight becomes a metaphor for transcendence. At Heathrow:

We are no longer citizens with civic obligations, but passengers for whom all destinations are theoretically open, our lightness of baggage mandated by the system. Airports have become a new kind of discontinuous city, whose vast populations, measured by annual passenger throughputs, are entirely transient, purposeful and, for the most part, happy.

We are all aware of the dislocated nature of contemporary urban life and deal with its discontinuities daily, but in the modern airport such tensions are defused, since its 'instantly summoned village life span is long enough to calm us, and short enough not to be a burden'. Augé agrees:

As soon as the passport or identity card has been checked, the passenger for the next flight, freed from the weight of his luggage and everyday responsibilities rushes in to the 'duty-free' spaces, not so much, perhaps, in order to buy at the best prices as to experience the reality of this momentary availability, the unchallengeable position as a passenger in the process of departing.[35]

Mobility is just one of the products now on offer at the modern airport. In response to the demands of an ever-expanding consumer society most are being transformed into vast shopping concourses. They nurture the passenger caught in limbo. The shopping mall is another simulated world, located on the outskirts of the city, served by the motorway and best reached by car. Sociologists note how peripheral areas have given rise to multiplexes and retail outlets and are frequented by what they call car-borne

'parkaholics', who seek the 'out-of-town' experience. The shopping centre is a self-enclosed and self-regulating public arena – more condensed than the average high street. With air conditioning and artificial lighting, the exterior is interiorised. Multiple floors are connected by escalators, and our circulation is as directed and controlled as the air flow. The shopping mall is a virtual world; we know it is a fiction but we read it as reality. Bluewater in Kent is one such environment, visited by over 26 million people each year, accessible via the M25 with parking spaces for 13,000 cars. The American architect Eric Kuhne called it a new kind of city, a resort, whilst Iain Sinclair has portrayed it as 'A one-night stopover, an oasis for migrants',[36] comparing it to a Channel port like Dover or Folkestone, where one finds the same 'dizzy sense of impermanence'.

A new kind of transient England is coming into being. The motorway service station, the shopping mall and the airport lounge could be seen as representative of this.

We increasingly inhabit artificial and transient environments, so it is hardly surprising that in this digital age we can imagine ourselves as part of a community even when our bodies might be separated by continents and we do not see each other very often. We might only know each other through an electronic name, and we might frequently create different identities for ourselves. It is hard to know where we are and where we belong.

Augé sees the users of the contemporary landscape as people who are no longer inhabitants in the traditional sense of the word – we are more like passers-by. Because we are constantly moving we have no sense of belonging. We work and play in virtual worlds, we multi-task, we drive (or are driven) everywhere. We need a new language a grammar of some complexity, to describe the world – not as it used to be, but as it is: 'a world of global computer and communication networks; of distributed intelligence; of interactivity; of connec-tivity.'[37] What we think of as reality is a fiction that has been created for us, and by us. Artists like Opie are trying to make sense of the world in these terms. His brand of fiction is direct and matter-of-fact, but its latent content is far more complex and evocative.

We live inside an enormous novel. It is now less and less necessary for the writer to invent the fictional content of his novel. The fiction is already there. The writer's task is to invent reality. In the past we have always assumed that the external world around us has represented reality, however confusing or uncertain, and that the inner world of our minds, its dreams, hopes, ambitions, represented the realm of fantasy and the imagination. These roles, it seems to me, have been reversed. The most prudent and effective method of dealing with the world around us is to assume that it is a complete fiction – conversely, the one small node of reality left to us is inside our own heads.[38]

I DREAMT I WAS DRIVING MY CAR
2002 [95]
Inkjet on paper
Billboard installation, Long Island City; commissioned by The Museum of Modern Art, New York

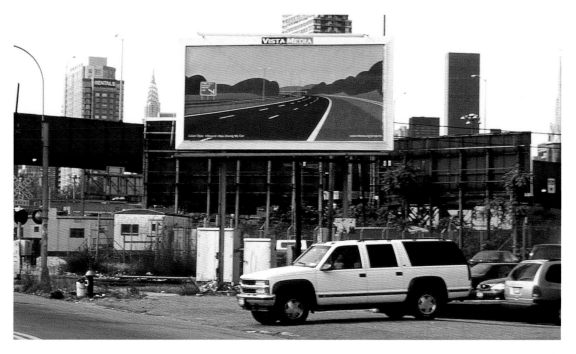

Notes

1 All Opie quotations unless otherwise stated are from conversations held with the author between 2002 and 2003.

2 Marco Livingstone, *Pop Art – A Continuing History*, London 1990, p.234.

3 Julian Opie quoted in *Tate Gallery Catalogue of Acquisitions* 1982–4, London 1986, p.296.

4 Mel Ramsden and Michael Baldwin, 'Julian Opie's Sculpture', *Julian Opie*, ex. cat. Lisson Gallery, London 1985, p.8.

5 Michael Craig-Martin, *Young Blood*, Riverside Studios, London, April–May 1983.

6 Andrew Graham-Dixon, *Independent*, London, 8 March 1988.

7 Richard Cork, 'In a Hurry', *Listener*, London, 2 May 1985, p.34.

8 Lynne Cooke, 'Julian Opie and Simon Linke: Two Young British Artists, Who Are Also Good Friends, Speak About Their Work And Their Context Internationally', *Flash Art*, No. 133, April 1987, p.37.

9 Lynne Cooke, *documenta 8*, Kassel 1987, Band 2, p.180–1.

10 Michael Newman, 'Undecidable Objects', *Julian Opie*, ex. cat. Lisson Gallery, London 1988, n.p.

11 Ibid, n.p.

12 Kenneth Baker, *OBJECTives*, ex. cat. Newport Harbor Art Museum, 1990, p.190.

13 Ulrich Loock, *Julian Opie*, ex. cat. Kunsthalle Bern/Secession, Vienna 1991, n.p.

14 James Roberts, 'Tunnel Vision', *frieze*, issue 10, May 1992, p.31.

15 Liam Gillick, *Art Monthly*, no. 174, 1993–4, p.26.

16 Julian Opie quoted in *Julian Opie*, 9th Indian Triennale, British Council, New Delhi 1997, p.17.

17 Tom Lubbock, 'Simple Pleasures', *Independent*, 25 September 2001, p.10.

18 Julian Opie interviewed by Gemma de Cruz, *Habitat Art Club Booklet*, Winter 2001, n.p.

19 Julian Opie, interviewed by Louisa Buck, 'Logo People', *The Arts Newspaper*, no.111, vol.XII, February 2001, p.37.

20 Michael Craig-Martin in an interview with the author 26 November 2002.

21 Nicholas Logsdail in an interview with the author 12 December 2002.

22 Julian Opie quoted in *Julian Opie*, Gouverneurstuin, Assen 1997, p.37.

23 Richard Dorment, *Daily Telegraph*, 2 November 1994.

24 Julian Opie quoted in *Julian Opie*, 9th Indian Triennale, British Council, New Delhi 1997, p.34.

25 Ibid., p.43.

26 Michael Craig-Martin, *Minimalism*, ex. cat. Tate Gallery Liverpool 1989, p.7.

27 J.G. Ballard, *The Drowned World*, London 1965, p.14.

28 Marc Augé, *Non-places: introduction to an anthropology of supermodernity*, London 1995, p.78.

29 Will Self, *Grey Area*, London 1996, p.91.

30 Michael Bracewell, *The Nineties – When Surface Was Depth*, London 2002, p.285.

31 Marc Augé, op, cit., p.98.

32 David Lawrence, *Always a Welcome – the glove compartment history of the motorway service area*, London 1999, p.103.

33 Andrew Graham-Dixon, *Independent*, London, 9 November 1993, p.25.

34 J.G. Ballard in *Airport*, ed. Steven Bode and Jeremy Millar, Photographer's Gallery, London 1997, pp.120–1 op. cit.

35 Marc Augé, op. cit., p.101.

36 Ian Sinclair, *London Orbital*, London 2002, pp.388–9.

37 John Thackera in *Airport*, op. cit., p.69.

38 J.G. Ballard, introduction to *Crash*, London 1995, pp.4–5.

Biography

Awards

Solo Exhibitions

Group Exhibitions

1994 *The Institute of Cultural Anxiety: Works from the collection*, Institute of Contemporary Arts, London

1995 *Drawing the Line*, South Bank Centre touring exhibition. Cat.

1997 *Material Culture: The Object in British Art of the 1980s and 90s,* Hayward Gallery, London
Artists for Sarajevo, Fondazione Querini Stampalia, Venice. Cat.
Follow Me, British Art on the Elbe, Art Studio, Deinste, Germany. Cat.
Art in the City, Kunsthaus Bregenz and Bregenz Kunstverein, Bregenz, Austria. Cat.
Need for Speed, Kunstverein Graz, Graz. Cat.

1997–8 *9th Triennale-India*, Lalit Kala Akademi, New Dehli; travelled to Chandigarh, Bhopal, Calcutta, Bangalore and Bombay. Cat.

1998 *Then and Now*, Lisson Gallery, London
Distinctive Elements, (organised by the British Council), Contemporary British Art Exhibition, The Museum of Contemporary Art, Seoul, Korea. Cat.
Every day, 11th Biennial of Sydney, Sydney. Cat.
Kimpo International Sculpture Symposium, Sculpture Park, Korea. Cat.
Surfacing contemporary drawing, ICA, London. Cat.

1998–9 *Thinking Aloud*, Kettle's Yard, Cambridge; Cornerhouse, Manchester; Camden Arts Centre, London. Cat. South Bank Centre Touring exhibiton curated by Richard Wentworth

1999 *In the midst of things*, Bournville, Birmingham, UK. Cat.
The Space Here is Everywhere, Villa Merkel, Bahnwarterhaus, Esslingen,
Art in the City 4, Kunsthaus Bregenz, Bregenz, Austria

2000 *Sitooteries*, Belsay Park, Newcastle-upon-Tyne
Parklight, Clissold Park, London. Cat.
New British Art 2000: Intelligence, Tate Britain, London. Cat.

2001 *Landscape*, British Council touring exhibition opening at ACC Gallery, Weimar: travelling to House of Artists, Moscow; Peter and Paul Fortress, St. Petersburg; Gallería Nazionale d'Arte Moderna, Rome; Centro Cultural del Conde Duque, Madrid; Sofia Municipal Gallery of Art, Bulgaria; Museu de Arte Contemporánes de Niterio, Rio de Janeiro; Museu de Arte de São Paolo; Le Botanique, Centre culturel de la communauté française Wallonie-Bruxelles. Cat.

2002–3 *Trespassing: Houses x Artists*, Bellevue Art Museum, Washington, MAK Center for Art and Architecture, Los Angeles and MAK Vienna. Cat.
Total ⸢berzogen, Edith-Russ-Haus für Medienkunst, Oldenburg, Germany Lenbachhaus Kunstbau, Münich

2003 *Arcadia; the other life of video games* Govett-Brewster Art Gallery, New Zealand.
Bienal de Valencia Valencia, Spain
No Art – No City: City Utopias in Contemporary Art. Stadtische Galerie, Bremen, Germany

Public Projects, Multiples and Special Publications

1994 *Imagine you are walking*, Wormwood Scrubs. Perimeter Wall Paintings, HMP Wormwood Scrubs

1994–5 *Cinq bâtiments de banlieue*, FRAC Aquitaine, commissioned for the Cloister of Annonciades, Bordeaux
The Tate Gallery Christmas Tree, Tate Gallery, London
Sculpture, The Economist Plaza, London

1997 *Imagine you are moving*, Commissioned and Funded by BAA Plc as part of the BAA Art Programme in association with the Public Art Development Trust, Heathrow Airport, London
Outdoor Portrait Gallery, Tate Britain, John Islip Street
Outdoor project for Wolkswagen/Stadt Wolfsburg, Wolfsburg
Sitooteries, Belsay Park, Newcastle-upon-Tyne
St Etienne: CD/album cover; poster campaign
Cruise ship on Lake Constance, organised by Kunsthaus Bregenz
Best of Blur: record and album covers + campaign (posters, objects)
I remember her multiple for 'art of this century', New York
'B4B', Baltic, Gateshead, England
Wall at WAM, a mural commissioned for Worcester Art Museum, Massachusetts
Tribe Art Commission 2002 (curated by Artwise for the BAR Honda Formula One Team)
Sculptures for the lobby of the new Dentsu Building, Tokyo, Japan

2003 Drop Sheet to clad the West Wing, St Barts and the London Hospital, London (curated by Field Art project)
Selfridges Store, Manchester (curated by General Assembly)

Visual Arts at Sadler's Wells, London
12 Large Banners Women Undressing, K21, Kunstsammlung Nordhein-Westfalen, Dusseldorf, Germany

Books and catalogues

1983 *Making Sculpture*. Tate Gallery, London. Cat.

1984 *Julian Opie*, Kölnischer Kunstverein, Cologne.Cat. text by Wulf Herzogenrath and Kenneth Baker

1985 *Julian Opie*, Lisson Gallery, London. Cat. texts by Michael Craig-Martin, 'Art & Language'
Drawings 1982 to 1985. Institute of Contemporary Art, London. Cat.

1987 *Julian Opie*, Documenta 8. Cat. text by Lynne Cooke, Kassel
Britannia, Paintings and Sculptures from the 1980s. Sara Hildén Art Museum, Tampere, Finland. Cat.

1988 *Europa oggi/Europe now*, Amnon Barzel (ed.), Museo d'Arte Contemporanea, Prato. Cat. text by Michael Newman
Julian Opie, Lisson Gallery, London. Cat. text by Michael Newman

1990 *The British Art Show 1990*, The South Bank Centre, London. Cat. texts by Caroline Collier, Andrew Nairne and David Ward
OBJECTives: The New Sculpture, Newport Harbor Art Museum, Newport Beach, California. Cat. text by Kenneth Baker

1991 *Objects for the Ideal Home, The legacy of Pop Art*, Serpentine Gallery, London. Cat.
Julian Opie, Kohji Ogura Gallery, Nagoya, Japan. Cat. text by James Roberts

1992 *Julian Opie*,Kunsthalle, Bern and Vienna Secession. Cat.

1993 IN SITE/*New British Sculpture* and *Threshold*, No.9, January. Museet for Samtidskunst, Oslo. Cat. and magazine texts by Karin Hellandsjo and Tim Marlow
Made Strange, Ludwig Museum, Budapest. Cat. text by Ann Elliott
Julian Opie, South Bank Centre, London. Cat. texts by Wulf Herzogenrath, Ulrich Look, James Roberts, Lynne Cooke, Michael Newman
Julian Opie, South Bank Centre, London. Exh. guide text by David Batchelor

1995 *Drawing The Line*, South Bank Centre. Cat. text by Michael Craig-Martin
Julian Opie, *Album Photos*, Calais, Le Channel, Scène Nationale de Calais

1996 Julian Opie, *Driving in the Country*, Tours, CCC. Cat.

1997 *Julian Opie*, Galerie Barbara Thumm, Berlin. Cat.

Follow Me, British Art on the Elbe, Deinste, Germany. Cat.

Art in the City, Kunsthaus Bregenz and Bregenz Kunstverein, Bregenz, Austria. Cat.

Every Day, 11th Biennale of Sydney. Cat. text by Simon Grant, p.172–3

Julian Opie, Gouverneurstuin, Assen. Cat.

Imagine You're Moving, Heathrow Airport Flight Connections Centre, Public Art Development Trust leaflet, text by Andrew Cross

Julian Opie, 9th Indian Triennale, New Delhi, British Council. Cat. text by Caroline Douglas and Julian Opie

2000 *Julian Opie*, Centre d'Art Contemporain, Meymac. Exh. calendar text by Fiona Bradley

2001 *Julian Opie – Lisson Gallery – Sculptures, Films, Paintings*, Lisson Gallery. Cat.

2002 *Julian Opie Wallpaper/ Holiday in Bali*, Atelier Augarten, Zentrum für Zeitgenössische kunst der Österreichischen Galerie Belvedere, Vienna. Cat. texts by Julian Opie and Thomas Trummer

Julian Opie, Galeria Mário Sequeira. Cat. text by David Barro

Julian Opie Portraits, Codax Publisher, Zürich. Text by Daniel Kurjakoi_ [???]

2003 *Julian Opie*, Neues Museum, Staatliches Museum für Kunst und Design, Nürnberg, Germany. Cat.

Articles and Reviews

1985 Richard Cork, 'In a Hurry', *Listener*, 2 May, p.34

1987 Lynne Cooke, 'Julian Opie and Simon Linke', *Flash art*, no.133, April, p.37–9

1988 Andrew Graham-Dixon, 'Pretty Vacant', *Independent*, 8 March

1990 Liam Gillick, 'Critical Dementia: The British Art Show', *Art Monthly*, no.134, March, p.14–16

Kenneth Baker. 'Physical Precision, notes on some recent sculpture', *Artspace* September/October

Parkett, 25, September, pp.143–8

1991 Michael Archer, 'I was not making a Monument, I was not making a Sculpture', *Art Monthly*, March, pp.3–5

1993 Tim Marlow, 'Julian Opie: Imagine there's another possibility', *Terskel/Threshold*, no.9, January, pp.49–63

James Roberts, 'Tunnel Vision', *Frieze*, Issue 10, May, pp.28–35

1993 Richard Dorment, 'Virtual Reality Comes to Toytown', *Daily Telegraph*, 1 Dec.

Waldemar Januszcaczak, 'Driving without a map', *Sunday Times*, 21 November, section 2, p.9

1993–4 Liam Gillick, 'Julian Opie', *Art Monthly*, Dec.–Jan., no.172, p.26

Michael Archer, 'Julian Opie', *Artforum*, XXXII, no.8, April, p.108

Richard Dorment, 'Her Majesty's Pleasure', *Daily Telegraph*, 2 November

Philip Sanderson, 'Julian Opie, Lisson Gallery', *Art Monthly*, no.198, London, July, p.25–6

1995 Angela Vettese, 'Simulated Architecture', *Domus*, Milan, no.767, Jan., pp.70–4

Lynne Cooke, 'Micromegas', *Parkett*, no.44, Zurich, July, pp.132–7, 138–45

1996 Francesco Bonami, 'Spotlight: Julian Opie', *Flash Art*, Nov./Dec., p.103

1997 Daniel Kurjakovic and Dominique Lämmli, interview with Opie, *Kunst-Bulletin*, no.3, pp.12–19

1999 Paul Morrison, 'Bonjour Monsieur Caulfield', *Contemporary Visual Arts*, issue 22, pp.26–32

2000 Lawrence Block, 'Pictures by Julian Opie', *Modern Painters* (cover), Spring 2000, pp.65–79

Charlotte Mullins, interview with Opie, 'The Lure of the Open Road', *Art Revew*, Prints, Autumn, pp.11–13

Gemma de Cruz, interview with Opie, Habitat Art Club booklet, Winter 2000/1, n.p.

2001 Jonathan Jones, 'A Gainsborough for the 21st century', *Guardian*, 28 Feb. 2001, p.25

Louisa Buck, 'Logo people', *Art Newspaper*, Feb., p.37

Pryle Behrmann, 'Julian Opie', *Art Monthly*, London, March, pp.31–3

Tom Lubbock, 'Simple Pleasures', *Independent*, 25 Sept., p.10

2002 Niru Ratnam, 'A Chequered History', *Contemporary*, June-July-August, pp.74–6

Works in Public Collections

Arts Council of Great Britain
Contemporary Art Society, Britain
The Tate Gallery, London
Neue Galerie – Sammlung Ludwig
The Israel Museum, Jerusalem
Stedelijk Museum, Amsterdam
Wadsworth Atheneum
The British Council
Fundacion Caja de Pensiones, Madrid
Kunsthalle Bern, Bern
Museo d'Arte Contemporanea Prato
Deutsche Bank, Frankfurt
The Calouste Gulbenkian Foundation, Portugal
Lenbachhaus Stadtische Galerie, Munich
Banque Bruxelles Lambert, Bruxelles
Museet for Samtidskunst, Oslo
Kunsthaus Bregenz, Bregenz
Dresdner Bank, Berlin
Museum of Modern Art, New York
National Portrait Gallery, London

Index